Constance DeJong

READER

Constance
DeJong

PRIMARY
INFORMATION

CONTENTS

1982
UNPUBLISHED MANUSCRIPT
EXCERPTED IN *BOMB* 4 (FALL 1982)
REVISED FOR *TOP STORIES*, 1983

CHARLOTTE SNOW,
ACCORDING TO HER FRIEND FRANCINE ROSE

The first time Charlotte came over there was rain, one of those soft gentle rains that go deep. "Fine for the country," Charlotte said; but we were having lunch under my skylight where that gentle April rain became a steady drip drip drip. The next time it was the sun, a bleak glare I never noticed until we sat there under the skylight unable to breathe without sending up clouds of dust. It was under the pretext of eating we kept on meeting, circling slowly and fixedly around lunches, dinners, late-night snacks, meals ever later in the night. Charlotte liked the night because it was always young. She liked eating in public places where for hours we could sit unnoticed, giggling like girls— girls who had no need for the likes of a boy. As if to demonstrate this, Charlotte would sometimes pencil on a moustache and order a big cigar. She liked only restaurants where cigars could be had, cigars and clean bathrooms, and eventually she liked only one restaurant: Lady Astor's. It had a corner booth with velvet curtains which, for a price, the waiter would close with a smile. She liked this best of all: privacy in public. And in there, a girl I was not. Neither was I a woman. I was legs and arms, bumping legs and arms forever knocking over the wine bottle. I was eyes, they got caught, locked in the longest moment, the moment of recognition. I had a mouth with words flying out of it, words that collided with hers. The collision produced a startling mutation of a language; the deepest of privacies was this. This gave us more than food, than sex, more than a body knows. We were indistinct from our mutated language, our intricate system of intimacy. That was who we were. To exist like that we had to meet more, more. I made the arrangements, made the Lady Astor's waiter smile really big. And there in our curtained booth we evolved, producing a mutation of the mutation as our dialect gave way to crypto-speech. With initials we encoded vast subjects. Initials, our dots and dashes, also tapped out the lesser topics—the CGs (cute guys or witless souls trapped in good

bodies) and the occasional A double C double S (academic clothing covering some kind of structure or not-dumb man). When Charlotte was between jobs she made a living practicing OC (outfit control, or designing clothes for the fashionable set). And when she had to leave town unexpectedly she sent me a telegram: "Everyone in the C is on IP. Not my I of L. Not even CBNC. K's x 10, PS." Or, "Everyone in the City (New York) is on image patrol (modern narcissism). Not my idea of life. Not even close, but no cigar. Lots of kisses, PS."

(According to Francine, Charlotte always signs her messages PS to indicate there will be more coming, and in her replies, Francine always underscores her signature with the address, the site where everything began.)

32 EAST FIRST STREET, NEW YORK CITY

Late in February 1980, Ricky Dent was assigned to keep an eye on Havana Lamotte, a tenant in the basement of the building. Havana was new to New York's Lower East Side but not to intelligence. She would always be under surveillance for the sympathies announced in her name; a rare instance of there possibly being an answer to the worn-out, the usually rhetorical: What's in a name? A questioning type the super at number 32 was not. To him, "Havana" announced soul mate, a not-so-rare claim filed under another story altogether.

The more pertinent file:

Havana Haydee Lamotte, no known aliases. Born 1952, Artemisa, Cuba. Father, Ramon, left Cuba with mother, Beatriz, in February 1958. Ramon Lamotte died under mysterious circumstances in April 1958, though a preliminary investigation into his "drowning" turned up no underworld ties, insurance policies, etc. Conclusion: suicide. Beatriz Lamotte became active in anti-Cuban (communist) activity around the time of her daughter's birth. She has gone on public record—May Day

party, Miami, 1970—to the effect that the daughter, Havana, is a legacy of Castro's Cuba. For details regarding sexual relations between Beatriz Lamotte and Fidel Castro and any subsequent "issue"—see M-14, paragraph 73. Mother Beatriz's comment regarding legacy may indicate the daughter, like herself, was to become active in the NY–Miami mouth network, disseminating propaganda.* Beatriz Lamotte retains same address since her husband's immigration: 3718 Fairlawn Drive, Coconut Grove, Miami, Florida. Havana Lamotte makes irregular but frequent trips between the mother's home and New York, where she maintains no permanent address.

*Considering Lamotte's family background, there is always the very likely chance she is involved in something more.

Always the very likely chance she is involved in something more, something …

It was a long time since contract agent Ricky Dent had been active in the anti-Castro campaign, had approved of such proposals as infusing Castro's shoes with a chemical that would cause his hair to fall out. But once reactivated by the Lamotte assignment, Dent worked double-time, almost instantly closing the gap between Havana Lamotte in the basement of number 32 East First Street and Francine Rose upstairs under her skylight. His logic was assisted by evidence: Lamotte's twenty-four-hour courier service and Rose's personal correspondence, a handful of documents written in "code." Included were messages received, drafts of replies sent, scraps adrift from the sender-receiver matrix pointing to the likelihood of bigger operations circling out from a clump of papers dropped in the trash can. Another point. Dent found other assistance drifting along the littered Lower East Side streets, streets given to all manner of paper artifacts.

- The Seventh Precinct police have reams of records with statistics characterizing the environs as a fourteen-by-seven-block area where there are more murders committed than anywhere in Manhattan, except Harlem.
- The NYU graduate library has several PhD theses written by aspiring urban sociologists concerned with the unusual and complex demographic features of a multiethnic, multiracial contiguity and, as gentrification slips into the vocabulary, theses swell, shelves lengthen.
- The quotidian is printed up in big pictures and a little bit of text, the local dailies' reports of the week's obligatory three-alarm fire, drug bust, body in a bag wedged between two abandoned buildings. And the less frequent "human interest story": Is the richest city in the world becoming like Calcutta, New Delhi, places where the street is a dormitory, rows of poor bedding down at night?

By daylight the city's homeless appear larger than life, like the TV character, Hulk, whose body expands to giant proportions, though the humans in question here may have no muscles at all. These giant forms may be tiny people built up from layers of clothing, from wrappings of paper and plastic, muffled to the chin, the face exposed, the construction continues. Heads are turbaned or bedecked with countless caps or with just one hat made from brown bag after brown bag fitted one inside another. Embellishing surfaces are idiosyncrasies of adornment—more buttons than a general, pop-top medals, aluminum-foil fringe, magnetic-tape streamers, safety pins, paper-clip garlands, more stuff made in USA. Not French, not on the LES.

A reporter from one of the dailies made such a mistake in identification when attracted to one of the more fashionable homeless. Her idiosyncratic taste—rhinestones and dime-store jewels, anything that glitters. Any resemblance to a French woman

was an overeager journalist's splice job: a glittering old woman alive in 1980 on First Avenue/La Môme Bijou-Miss Diamonds, already old in 1932 in a Montmartre night spot.

A little research at a library would have steered the reporter to moments when Ziegfeld Girls appeared regularly in back-page tidbits of the *Herald*'s morning editions. Having been seen at certain parties, escorted and twirled through after-hours life, the Girls made sparks in the daily machinery, some of which did not just fizzle out. Some big wheels and a smoking-gun tidbit march from the gossip column onto the front page.

STANFORD WHITE SHOT DEAD
BY MILLIONAIRE HARRY THAW:
PLAYBOYS IN THE GARDEN

The time is 1906; the place, Madison Square Garden; the incident migrates onto more recently written pages.

"… it seems established that White, although a devoted husband and father, was also a determined seducer of young girls.

"In 1901, White met a showgirl called Evelyn Nesbitt, from Ziegfeld's Floradora chorus. She was then sixteen, and looked even younger, but White seduced her. The millionaire Harry Thaw, who was jealous of White on various other grounds, also admired her. Thaw eventually married her, in 1905, suffered greater jealousy, and shot White dead fourteen months later in Madison Square Garden's restaurant."

Writing in 1976, Martin Green also notes: "Thaw, too, saw himself as a great lover and bravura personality. When he came into his fortune on his twenty-first birthday, he gave a dinner for a hundred actresses, each of whom found a gift of jewelry beside her plate."

A hundred actresses wadded up in three words, seventeen characters of type, a spitball sailing out of sight. Winifred Abel, Irene Arnold, Yvonne Bendowski, Virginia Blatt, Carlota Bohm,

Minnie Briscoe, Adele Brown, Naomi Buchanan, Isabell Capota, Ardell Capra, Rosemary Claire Casey, Josephine Cuomo, Olive Daphnis, Opal Dauber, Pearl Dauber, Wilhemina Dean, Esther DeGarcia, Gladys Vista Dixon, Hattie Doniger, Lili Dorn, Blanche Drakonakis, Pauline Durkin, Sarah Eberhard, Iris Ehrlich, Maxine Emspack, Lydia Evans, Frieda Evers, Catherine Fanning, Edith Fisberg, Lillian Flores, Dora Fortini, Veda Fuchs, Amelia Gelfand, Meredith Glazer, Annabell Green, Stella Guest, Flo Harrison, Jeanette Hart, Dot Herman, Henrietta Hopkins, Crystal Hutchins, Anna Ivany, Cora Jessup, Lili Jones, Angeline Jusino, Faye Kaiser, Mildred Keely, Ruby Kelley, Cecelia King, Joan Louise Koblenz, Phoebe Koppel, Esther Kozic, Louise LaBarbara, Hannah Landau, Edna Lord, Eloise Maxfield, Patricia McBride, Sylvia Miller, Hazel Moran, Ada Mullter, Myra Neff, Allegra Nugent, Margaret Nye, Catherine O'Hagen, Marion Oliver, Eugenia Owings, Evelyn Pesking, Ava Phipps, Ginnie Pomeranz, Bea Purdy, Geraldine Putnam, Christine Rhodes, Nadine Richter, Virginia Ricks, Louisa Robertson, Agnes Ross, Hope Rupenthal, Beatrice Samuels, Dawn Sawyers, Celia Schneider, Ethel Schultz, Cynthia Shatkin, Isabell Snyder, Emmaline Swazey, Madeline … the litany like the F train stops here at the intersection of First Street and First Avenue.

At five o'clock: traffic backed up for minutes on end, block on block of cars momentarily caught in the First and First nexus. Quadrophonic leakage from car radios tuned to *Shadow Traffic* sent down from helicopters on the watch for gridlock. On the respective four corners, much of the world is represented here. Abandon the orderly right angles of intersecting streets for *nexus*, two crossing diagonals, an X. Jews and Arabs occupy the ends of one axis, and on the other, the more obscure coupling of Eastern Europe and the Mediterranean, a Polish restaurant opposite a quick-stop café run by Greeks. Aside from corners tacked down by national-identity businesses, minority groups claim the surrounding area as home, as do individuals living in varying degrees of anonymity and flamboyance,

disorderly crowds heading homeward at five o'clock, jaywalking the First and First intersection, the X, it's home base for Madeline Tarkington. Or Mad Madeline, as she's known. She's known for such peculiarities as reeling off names in alphabetical order seventy-five years after the fact; for delivering whole punctuated paragraphs when senility shifts from the singed pinpoint of a smoking gun, when the fog that comes with age recedes to reveal a vista.

The pinpoint. Mothered by a showgirl, Madeline is one of uncounted people biologically fathered by Stanford White, left with a dangling genetic blank spot, nothing to flesh it out.

The vista. All-night fruit markets, flower stalls, liquor stores, newsstands, you could get anything you wanted at all hours on Eighth Avenue. We lived around here to be near the theaters and agents, a district full of small studios with one window on an airshaft. Mr. Fishbach, he had seventy, eighty, one hundred of them in his row houses and he didn't bother much with formalities, just pulled out a lease-like paper with a room number at the top followed by rows of dotted lines. You signed, crossing out the name above. Only women tenants, that was about his only rule, and it had him hauling his 225 pounds of overweight back and forth in front of his buildings, chain-smoking Camels, muttering about "my girls." We came to him through the grapevine, went away when someone gave up or got a better job or married. Sad goodbyes, happy goodbyes, and a lot of resentment because I couldn't tell which was which, work/marriage. I always said at least there's more to alimony than unemployment checks, good luck. I always bombed with the girls. Didn't like my jokes, didn't like how I wouldn't share my studio, how I never went around after the show with some decent-looking guy. Then I got my hair cut. So. I was a lesbian after. And why would I blow the whistle on gossip? At home it gave me some privacy, and the very idea kept the girls from stretching their imaginations far enough to see me going down to the piers. Early in the morning, even with eyes swollen from lack of sleep, there's no mistaking that pretty swaying movement through the haze lifting off the water. See them

little behinds coming down the gangplank. Each one, each one alone is even more pretty—a swell of smooth muscle flinching a little at the first kiss of concrete sidewalk on the sole of a black polished shoe. Sailors. You linger for a moment and they're moving off, bunches of spit-shined toes pointed toward Midtown. Thank god for wind. Still two of them trying to light a match—quite the pair, Mr. Mutt and Jeff, though the tall one didn't think so. Didn't think much of my hairdo, either, until it got topped with his cap. That's how they do it, cap you for a weekend. And the short one, Pascal, he shook his head slightly and backed off a few steps. Roger was so much taller, he had to lean down to kiss that sad face. When Roger patted him on the bottom, the sad boy fiddled with his buttons, and with Roger's arm around his shoulders, Pascal said nothing all the way to the Village—just more long faces when the coffee finally came.

"You think this American coffee's shit. I'll tell you what's shit. You, if you don't stop whining. What if I leave you on your own, just you and Louie, eh? Then see how it goes."

Pascal's going got better after that. All weekend he never peeped about sleeping on the floor of my tiny foyer with his feet in the closet. On the last morning he was still being charming when he climbed into bed. Laying his head on Roger and peeking through those curls of chest hair, he asked very sweetly if I'd come down for a goodbye wave. I agreed, since it was November, cold enough to pin on my new raccoon collar, enjoy my first hot chocolate of the season, even better, some hot buttered rum. A lot of that got drunk the day the *La Sylvette* sailed. In its seven staterooms passengers were probably listening to their friends' I-told-you-so about booking passage on an old freighter. After a three-hour delay with engine trouble their champagne was gone, also their bon-voyage spirit, which was still going strong among the girls come down to see off their sailors. We didn't mind not being allowed on board, not on the corner of Water Street where rounds of rum only cost a dime. In Smokey's we didn't mind anything. Except for Jeanette. "My Charlie," she wailed, holding up

her glass. "Oh, come on, Jeanette. How can you cry for one Charlie when there's a boatload of them out there?" And you can bet they weren't looking too pretty down there in the hold, sweat dripping between the cheeks of those hard little butts, dirty jerseys sticking to their chests. Forget about pretty down there. Valves are being opened, cartons restacked. With luck a guy can duck out of the terrible heat and noise for a quick smoke. Hurrying sailors rib each other with a "make tracks punk," "hey baby dig my hard-on," "oh beat off." And always on the move down those narrow corridors, there's a figure casting a shadow over every inch of the ship. Forget about the captain. Remember the name, Louie Paradise. He had a ticket all right. Dope, that was Louie's ticket: morphine sewed in the lining of his jacket, sold to the lonely, the homesick, anyone dumb enough to get hooked on it. The fun started when the needle-happy ran out of money. Halfway across the Atlantic without a sucker to put the touch on, they'd come whining to Louie and he'd meet them in the showers. He liked playing god in there, ordering them down on their hands and knees, sticking it to them in the ass. Maybe no one heard Louie scream the night Pascal took it in the mouth, but if Louie was out of commission for a few days with some teeth marks on his meat, that was nothing compared to the infected track mark running up Pascal's leg. One dirty needle was all it took and the *La Sylvette* sailed into Marseilles with a stiff in its stow. The captain escorted Louie to the chief of police. A half hour later they were standing on headquarter's steps, buttoning up their peacoats, the mistral in their ears. When the newspapers asked for a statement, the chief said, "That's what the Marseilles hoodlums do, they kill each other." Think of it, think …

The fog is back, the blurry trail is about death on a ship, it's like murder in a hotel, the air never quite clears, little things bring it all back.

Three picture postcards held together with a rubber band
Burnt toast
Dead batteries

Little things are piling up around Madeline as she forages in the garbage for the stuff of her material life ordered according to edible, usable, beautiful. In the reject pile go loose pages, scraps adrift from the sender-receiver matrix.

"Take 'em, Sonny. Take 'em if you're that dumb."

And take 'em he did, "Sonny," aka Ricky Dent. When he waved his evidence under Francine Rose's nose, the smell of garbage was sweeter than the odorless creep of fanaticism, desperation. And the confusion. Had Dent concluded that coded messages descended to the basement to be disseminated into the world, or was it the other way round? Lamotte scurried back from her contacts to the woman upstairs who disguised secrets in the letters of the alphabet. Francine's attempts to make sense of Dent's angle belabored her conversations with friends, whose attention spans had been taxed by efforts to grasp what had actually transpired under drops of rain, among particles of dust, behind velvet curtains; by efforts to puzzle out what third person had provided information about the nexus point linking all that to-ing and fro-ing of street people, agents, guns. Ricky Dent packs a .38 automatic, a German-made piece of perfection popularized by 007 spin-offs. But weary of details, friends grew impatient with the Dent business, began to ask questions and talk among themselves.

"Was it likely that so complicated a plot would depend on the unwitting cooperation of one mercurial young woman about to leave for England?" Or: "Francine Rose. An obsessive personality! Always making a federal case out of her own personal problems."

No one said: what one really is, is knowing oneself as a product of a historical process to date that has deposited in you an infinity of traces without leaving an inventory; the job of producing an inventory is the first necessity. Or, that many people find their way to the general through the personal, the individual. Those are quotations under-lined in books Charlotte Snow was reading in a bedsit in Islington, a borough of North London where she'd taken up residence. She'd described the situation in a letter to Francine:

I'm becoming a repository, a compendium of statements that're being committed to memory. Someday I'll be like a vast, indexed reference book that can flip to its own pages at will. Naturally there's a trick, a system. I'm using one described in *The Art of Memory* by Frances A. Yates, a medieval system … too intricate to go into here. But essentially you image a building constructed of rooms, and each room gets a designated subject heading where particular material's stored. So the material's not just conserved: it also can be located in a flash. Among other things one has to keep the imaged structure from becoming some dizzying and dumbfounding edifice that will topple over. Sound looney? So is living in an Islington building crawling with armchair radicals tossing off buzzwords and received ideas, pearls before the American swine, me, who's wandering down the hallways of medieval metaphysics. Still, the system seems to be working. My imaged building is a standard suburban house, and when I got your letter about upstairs-downstairs Dent, I went into the closet and flipped directly to *Conspiracy*, A. Summers: "The American intelligence community is so sprawling a creation that it spawns compartments where not even those in charge can be sure what is going on. One such was its anti-Castro division, consisting in 1962 of 600 Americans, most of them case officers, plus upward of 3,000 contract agents in and out of Cuba. The Americans no less than the exiles were committed to their cause. There was the proposal, for example, to infuse Castro's shoes with a chemical compound that would cause his hair to fall out. (Once bald and unbearded, his charismatic charm would disappear.) Also a specially treated cigar to make him incoherent during one of his speech-making marathons. Or spraying LSD in his broadcasting studio for much the same effect." Actually, Francine, when you first sent word of the Dent business I just rolled my eyes, and stuck there on the back of my eyelids was the old question we used to ask:

ITILOE? If your alpha-speak is a little rusty, I'll spell that out when you get here. I am dying to see you again. Please bring some news of Edgar Krebs and some all-cotton sweatshirts.

Much love,
PS

27 March 1980
Dear Charlotte,

Did you get the message I called? Whoever answers your hall phone isn't terribly cooperative. I had as much trouble getting across to them as I've been having with calls to West Bengal, ha, a subtle introduction to my change of plans. I plan to see you still in London but on the return trip in June. By then will your head be swollen beyond recognition, the size of that house you're stuffing with "material"? Or will you have invented something like the flying buttress to hold up your densely packed cranium? Technologists are working to invent computers that can think. So what's the idea of trying for the reverse, housing a storage and retrieval system, becoming a human computer that doesn't think? Such are my infantile terrors. I've always had a near phobia about mind control, waking up in *1984* with a Roman Polanski *Rosemary's Baby* script: "This isn't a dream, this is really happening." I want to say *the future is now* without sounding glib. I want shiny coin phrases. Not slogans stamped on buttons and T-shirts like hip brand names strangers use to find each other. Not frozen phrases like the educators' flash cards that teach you to recognize word groups in $\frac{1}{32}$ of a second, no meaning, let alone spelling. ITILOE? Not that either. Alpha-speak is everywhere from DDT to FMLN-FDR, both inescapable, poison and politics.

But when we see each other again let's work on the lost art of plain English, inefficient as it may be in a world of initials. The FMLN-FDR is a coalition of the Revolutionary Democratic Front (FDR) and the five guerrilla groups in the Farabundo Martí National Liberation Front (FMLN). These five groups are the Salvadorian Communist Party (PLS), the Popular Forces of Liberation (FPL), the People's Revolutionary Army (ERP), and the Armed Forces of National Resistance (FARN). Within each of these groups, there are further factions and sometimes even further initials, as in the PRS and LP-28 of the ERP.

Havana Lamotte has an equally complicated life story bound up in split factions, which as you say is too intricate to go into here, will have to wait till I meet you in the falling rain, June in London. In the meantime I'm getting to know Havana. She's staying in the spare room. We agreed that under the circumstances it's too symbolic for her to live below ground in the basement. Up here it's Insomniacs Anonymous. She tells me her nightmares, I tell her mine:

A woman wearing a red veil comes walking up a driveway from the far end where she's just stepped out of a shiny black car. She has some trouble negotiating the icy patches and the wind keeps blowing her coat straight. Then suddenly the wind dies and her key is turning in the front-door lock, her footsteps are on the stairs, even the silver charms of her bracelet are jingling, jingling in the quiet of the long windless moment …

What does it mean? Don't need a shrink for this one. Havana is haunted by an image of a three-piece suit packing a .38 Walther PPK and commiserating with Mad Madeline. Havana happened to see poor old M.M. going through the garbage on the afternoon Dent came snooping around in his three-piece. Meaning, one part of the puzzle's no longer a mystery. The papers I'd thrown out got recycled through M.M., and Dent, forgive me for saying, he never had to dirty his hands.

Enclosed is the part that haunts me. As you know, this recent event isn't the first time Madeline has intervened in our lives, and it's in your words that I register a little detonation, the sickening eruption of a déjà vu. Maybe there's a corner in our memory system for the enclosed article you wrote so long ago for, god help us, THE House Organ.

I'm writing at such length, sorry I'll try to be brief.

All-cotton sweatshirts are in the mail. Black and white and blue.

As for Edgar Krebs, he left for an early vacation without a word and our temporary super is Rudolf Brenner from next door who now goes by the name Rainer Berlin, rechristened for his favorite poet and the city of his birth. What he knows about Rilke and Berlin would fill a space the size of the tiny heart tattooed on his shoulder which carries a burden no heavier than the weight of a couple key chains looped through the epaulets of his leather jacket—just another character jingling along in his own movie, complete with sound effects. Oddly enough, he's scouting locations for an "actual" film he's involved with as the art director; some cops-and-robbers remake starring local leather-and-steel talent.

He thinks my apartment is perfect for it, all those points of view (!). Shots down through the skylight, up through the hole in the floor, tracking through the sliding door to next door ... dum da dum dum. If my apartment as film location pays the rent while I'm gone, I'm game. Rainer is still sweet Rudolf, still asks after. "Well, well, Rose Red, how is Snow White?" I didn't tell him not all women are attracted to fairy tales with One-Uprights stalking around. Anyway. Insomnia has me on the night shift. At this hour my assistants, strategically positioned around the apartment, are working tirelessly to keep the place reasonably together. A Roach Motel in the corner is collecting bugs on some surface, sweet and sticky. Under the stove a package of D-Con poison is inviting mice to a last supper. A small fortune passes hands for these and other contraptions such as a penguin-shaped one on the tap filtering

heavy metals out of the water, a pyramid-shaped ionizer revitalizing polluted air. I pay for contraptions sold by the same companies that produce the problems that destroy the house we all live in. Is that an example of my reputation for making mountains out of molehills? Mountains. When I go to them periodically for some fresh air and some kind of mental space that only comes with practice ... never mind. Some people jog, some sit very very still. It'll be more than nice to see you on my return trip. Some days I miss your company to the point of distraction. I think this was one of them.

Much love,
Francine
#32 E.F.S.

32 & 34 EAST FIRST STREET, NEW YORK CITY

A typical screwup. This morning when I came downstairs all the mail for number 32 had been delivered here to number 34 by mistake. People I don't know read *Newsweek* and *Soviet Life*, get thin blue aerograms from Dublin, bills from a West Side doctor, from a collection agency in Omaha. A typical screwup and too suddenly, there's a chink in the venetian blinds of people I don't know.

Numbers 32 and 34 are identical twin buildings, from the pink-and-black-tiled entrances to the matching skylights giving access to the adjoining roofs. There's a huge telescope up there when the weather permits. When nights are clear, our super searches for comets, the one he'll sight before any other amateur astronomer's known as a streak across the sky. If Halley did it, so can Edgar Krebs, he's fond of saying. He's fond of the ring of "Krebs's Comet," plans a traveling laser light show bearing that title, part of the someday when he leaves the roof and is an itinerant astronomer with his scheme packed up in a couple aluminum suitcases.

"Earth to Egbert, Earth to Egbert." I hear kids yelling in the hallway when they're not pumping quarters into *Donkey Kong* video games Edgar could probably program in his sleep. I hear footsteps overhead and rap three times on the skylight. Silence means calls the cops. Two raps mean it's Edgar conducting his rooftop vigil. I go up for a look. His sight is trained on his favorite target. "The fashionable world, a tremendous orb nearly five miles around, is in full swing, and the solar system works respectfully at its appointed distance."

ME A little respectful backing off seems perfectly in order since it's physical space, not knowledge, everyone's after. Let's call for a moratorium on greed. Hands off the sky, everyone zip up their pants and pipe down.

HE Oh, come on. The search for extraterrestrial life is, in the opinion of many, the most exciting, challenging, and profound issue not only of this century but of the entire naturalistic movement that has characterized the history of Western thought for three hundred years. What is at stake is the chance to gain a new perspective on man's place in nature.

ME Let's begin the search with fingering the question: Is there intelligent life on Earth? Is there a naturalist for attending to minute phenomena, for reading between the lines?

HE Don't go metaphorical on me. Facts, I want some plain solid facts. This isn't Egypt, we're not talking in riddles.

ME What is this civilization in which we find ourselves? What are the ceremonies and why should we take part in them? What are these professions and why should we make money out of them? Where, in short, is it leading, the processions of the sons of educated men?

HE Well, Alfred North Whitehead and Bertrand Russell had a fruitful collaboration, *Principia Mathematica*. Their work on "logistic language" had been preceded by efforts to produce an international language which would bring the world closer together. The first to be widely used was Volapük, invented in 1880 by an Austrian priest. This was followed seven years later by Esperanto, but the mathematician Peano felt these had failed to escape from the arbitrary and illogical syntax of tongues that evolved in the chance manner of nature. In 1903 he produced Interlingua, derived from classical Latin but with a simplified syntax. It is still widely used in abstracting scientific articles ...

(My ignored interruption: "Probably he has got no red blood in his body. Somebody put a drop under a magnifying glass and it was all semicolons and parentheses. Oh, he dreams of footnotes, and they run away with all his brains. They say when he was a little boy, he made an abstract of 'Hop o' My Thumb,' and he's been making abstracts ever since. Ugh!")

... and these developments have led Hans Freudenthal, professor of mathematics at Utrecht University, to attempt extending the "logistic language" of Whitehead and Russell into something intelligible to beings with whom we have nothing in common except intelligence. He calls it Lincos as a short form of *lingua cosmica*. The logical exposition of the language as might take place in an extended interstellar message is contained in his book *Lincos: Design of a Language for Cosmic Intercourse*. Actually, he pointed out, such a language may already be established as a vehicle for cosmic intercourse.

ME Great. Everyone speaking the same tongue, singing the same anthem. Fuck cosmic intercourse, celestial syntax.

HE I don't believe you, I really don't.

ME No one asked you to. Someone, however, is coughing in the shadows. Oh, it's Francine, hi.

As witnesses to Edgar's near-nightly vigil, Francine and I became familiar with all his schemes and with the practical side of his talents, which run to anything electrical, mechanical, even structural. He's helped us to make our apartments burglar-proof, our cranky radiators give off steam, and when we decided to make our lives simpler, he had us chipping through the correct spot in the common wall of our apartments. If Gulf & Western could do it, so could we. That was our scheme, mine and Francine's. If considered in the light of multinationals, our merger, a consortium of two, will not a big deal make. Neither will darkness make do, nor a gray zone where someone, however, *is* always coughing in the shadows, infecting the entire organism out to the extremities, our leaping-off site. No big deal, except for the laws of nature, which state that no two bodies can occupy the same space at the same time. Ricky Dent, his boss, would like to be a law that certain; know which bodies occupy what space when. They don't like, maybe no one likes, stratagem, deception, facts giving way to a sprawling fiction, the lives we live:

Two people become one on paper by drawing up a contract and pooling their resources to exist as a stronger economic unit, an imagined third person. Conversely, one person exists as many, a string of aliases and aka's. When originally Francine and I drew up our contract we provided for inevitable complications. For example, when Francine went away she replaced herself in the unit. Now Havana Lamotte upholds a share in domestic economics my salary cannot withstand alone.

I work in the Lincoln Center Library, Theater Division, where lives of performers are bequeathed to eternity. We disassemble their scrapbooks, organize their photographs, reviews, love letters; we cut, we paste. We, some of us, work late, after our bosses go home. The place then is ours, a treasure house of free stationery, this fluorescent-lit sanctuary where the free Xerox machine is humming away. I copy things for Francine.

A typescript: *TWICE-TOLD TALES, An Ecological Text made of Recycled Material*; adapted by Charlotte Snow; footnotes by Richard Burton; additional annotation by Gustave Flaubert.

An article: *AT NIGHT, The Biography of an Object* by Charlotte Snow. The object of this study is a piece of jewelry, or at least it was once all of a piece, a necklace of Egyptian origin associated with Hathor. Legend recounts that at the origin of time, men conspired against their creator, Re. After considering the matter, Re decided to send his Eye (consciousness) in the form of a lioness to chastise the insurgents. She was called Sekhmet, meaning "powerful," an aspect of Hathor. Sekhmet wrought havoc and would have devoured all humanity had not Re, stricken with regret, then had the ground covered with red-dyed beer in place of blood, so that Sekhmet, deceived by the color, drank up the liquid, became drunk and fell asleep, thus sparing mankind. This took place, however, very far to the south of Egypt. It fell to Thoth, lord of writing and time, to bring Sekhmet back into Egypt. Barely had the two arrived when Thoth plunged her into the waters of Abaton in order to "quench her heat." And thus the bloodthirsty lioness was transformed into the gentle cat, Bastet, one of the aspects of Hathor.

Not all is a lioness brought under control and made to pussy-foot through eternity.

Under the multiple names that evoke her countless aspects, Hathor represents a synthesis of Egyptian notions concerning cosmogenesis, and as such she is of a different dimension than Aphrodite, with whom the Greeks mistakenly identified her. For despite her female epithets, including "Mistress of Love," she isn't the Feminine Principle. Under the name Neith, for example, she is addressed as "Lady of Sais," meaning two-thirds masculine and one-third feminine.

I read the first page of the article while the Xerox machine hummed away copying things Francine needed in preparation for her departure. She's gone to mountains so high and remote not even the tools of surveillance travel that far. Sounds like she's escaping.

I.T.I.L.O.E.

More to the point, Francine lives with wanderlust contracted at an early age and reports this as fact:

There are places where there is no television yet: Darjeeling, which is perching at a high altitude and for days nothing, white nothing from the Windamere's windows, renowned hotel in the clouds. When a hard wind blows, Mount Everest is standing there and … Darjeeling is perching in foothills of the Himalayas. In these lowly heights, soft are the sounds arriving on a strange, flitting breeze, dizzying tease, oh jeez, please stop. And indeed one does become accustomed to always having an airflow in the head, to the unremitting rustle of silk prayer flags, of deep moaning prayers circling up from the valley. Monks down there have a hard-to-grasp notion of words as living things. Thus anything committed to writing cannot be destroyed unless the life of it is passed on in a ceremonial fire; colored smoke warming the atmosphere with the breath of life. At a far distance from the monastery, the Windamere is a relic of the British Raj still serving high tea on a landscaped terrace. A piece of paper caught in a bush makes a flap. I release it, a page from *Romeo and Juliet*, the part about love traveling from hand to hand, lip to lip. It makes me laugh, it always has, those two kids all bent out of shape and there's no one here to press them into the fabric of Darjeeling life. Local residents await the arrival of television, one set they'll watch in a movie house. I've come to a place where words are living things and where my Darjeeling friends await exotic reflections of faraway places. They look forward to seeing me on television after my safe journey home which as you know will be soon enough.

Love,
Francine

Francine's letters come to Havana and me at the 32–34 complex on East First Street addressed to Carol Riding, the so-called person who simplifies things, clears difficult economic hurdles, and yet. Carol, she comes into existence like neighbors glimpsed in a stack of envelopes; these I'm entitled to open—envelopes enclosing an unsolicited credit card from a second-rate rent-a-car company, catalogs promoting discounted makeup with a free sample, a request for a signature on a letter protesting the incarceration of Polish intellectuals, but no health insurance policy. No, instead of the one awaited document which would verify our intentional efforts, there comes only Hulk-ish unarrested expansion into a creature putting on lipstick in the rearview mirror of a rented car with license plates made by convicts as opposed to incarcerated intellectuals. That's not right. A woman is putting on her makeup before picking up a rented car, and on the way she drops a letter of protest in a mailbox. This woman has incessant conversations with Shepherd, a fanciful constant companion, a man I knew briefly in real life in days when the scheme, mine and Francine's, was young. Older is a dry clot of days punctured by dots, dashes, blank spots where caprice whispers and moans. It started Wednesday. An invisible hand relieved Havana of her handbag in a crowded coffee shop. Last night she received an anonymous call from a man in a phone booth on 125th Street and Amsterdam Avenue who claimed he'd found her wallet and other valuables, she could come and get them, he'd be waiting in front of Harlem Hospital. By morning it's still uncertain if the phone caller, who now calls himself Pinkie, will keep the second rendezvous; if his absence at the first was a true misunderstanding; if this isn't a classic setup in which the original thief receives a reward for returning stolen possessions as his partners burglarize the victim's apartment known to be vacant while she traipses uptown; if we aren't reasonably justified in assuming an absence of rectitude—"Of what?" Havana snaps, nerves running wild. It started as a joke. Where once I kidded about us assembling in Carol Riding a Frankensteinian creature that would probably turn on its makers, Francine was ever serious, responding

with a learned diatribe about *Reason, Rectitude, Justice*; three celestial Graces who appeared before a worrying woman in 1405 "to restore her senses, to explain to her the causes of antifeminism and to reveal womanhood's true nature, and at the same time, they will help her build a fortified city, an ideal city in which all noble women of the past, present, future can live undisturbed." When it seemed appropriate to the occasion of her leaving, of Havana Lamotte entering, Francine amended her diatribe, said the source of celestial reference, her friend Charlotte Snow, had strayed too far afield with medievalisms, things eerily Euclidean; at any rate, *we* could stick to the principle of the things. We could, for example, continue along the lines of the three Graces, in reaction to which Havana had said it was about time we discussed down-to-earth things, in particular that now anxiously awaited health insurance policy. But it doesn't come; only unsolicited envelopes, unwanted incidents, glimpses and snaps. If we are reasonably justified in assuming an absence of moral integrity, the dictionary's words for "rectitude," the dictionary isn't giving any pointers on how to proceed with a guy named Pinkie who may or may not be waiting in front of Harlem Hospital at noon, three thirty, five thirty, he can't make up his mind, his upper hand that jerks us around; us and our masked man, our day's dose of random disorder, and so it goes. Hours of relay phone calls to and from Havana, many particulars, reassessments of "personal business" conducted on library time under the watchful eyes of Millicent Gibbs, my supervisor ... after hours of this, I've a mind contracted to a sore spot, just the tight little curlicue of a snatched purse located in a throbbing muscle in my neck. I am not discussing it with Shepherd, with whom all conversation is on a non-tedious plane, is involuntary murmuring—high nonsense on the way home at rush hour. I am not the only one thus engaged, betrothed to phantom. Thousands rushing home and this woman, that man, many are of the murmuring lips. Many are mouthing their capricious mantras, whispers and moans, though rarely in the body-to-body tight quarters of the subway where I am a less-than-anonymous worker in

my fanciful midnight blue-black hand-me-down dress inscribed with love of night from Charlotte to Francine to me spit out of the train, hurrying, jaywalking.

Upstairs. I wind back the tin top of my kippers in front of the seven o'clock news. I hear kids yelling in the hall, footsteps overhead, three and two raps on a pane of skylight, and up on the roof, a dry peck for right cheek, left cheek. Edgar's back from vacation, returned to his near-nightly vigil, and up here all's very still. It's our tacit agreement to forgo scenes unworthy of repetition, it's our truce to realign a badly tallied invoice, all that he-ing and me-ing of:

- Ill-trained ideologues banging their solitary gongs
- Unmagic mediums through which passed two separate processions of ghosts talking
- Faulty instruments streaking the sky on a jumbled trajectory

Three minuses.

One plus—all's very still. It's a startling silence, it's the breathtaking quiet when a long, monotonous sound suddenly breaks off.

NOTES

P. 15 *"Thaw, too, saw himself..."* Martin Green, *Children of the Sun: A Narrative of "Decadence" in England after 1918* (New York: Basic Books, 1976).

P. 21 *"The American intelligence community..."* Anthony Summers, *Conspiracy* (New York: McGraw-Hill, 1980).

P. 23 *The FMLN-FDR is a coalition...* Joan Didion, "In El Salvador," *New York Review of Books* (November 4, 1982).

PP. 26 ME *A little respectful backing off...* "Ghosts talking" through "unmagic
−27 mediums." HE Charles Dickens (*Bleak House*), Space Studies Board of the National Academy of Sciences, Walter Sullivan (*We Are Not Alone*). ME Adrienne Rich (*On Lies, Secrets, and Silence*), Virginia Woolf (*Three Guineas*), George Eliot (*Middlemarch*).

P. 29 *Under the multiple names...* Lucie Lamy, *Egyptian Mysteries: New Light on Ancient Knowledge* (New York: Thames & Hudson, 1981).

P. 32 *"to restore her senses..."* Christine de Pisan, *The Book of the City of Ladies* [1405], trans. Earl J. Richards (New York: Persea Books, 1982).

I.T.I.L.O.E.

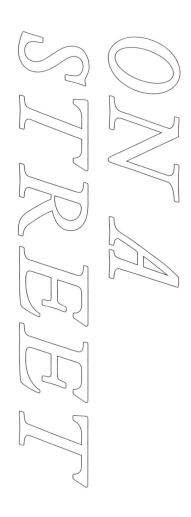

ON A STREET

2015
SPOKEN TEXT AND SOUND MATERIAL
INSTALLED ON VINTAGE RADIO
PERFORMED LIVE, 9:31 MIN.

You are on a sidewalk packed and fierce and fueled by desire greed ambition, come on come on miracle. Well, it is rush hour on Madison Avenue, the traffic lights have been newly set to change every thirty seconds snarling buses and taxis and cars and pedestrians are racing against the numbers—six five four—well done, you made it across the intersection three seconds to go. You would like to get home in under an hour for a change, you would like to live right here. The neighborhood averages three to five thousand dollars per square foot. A Chanel handbag, an ornate Chinese vase, an ensemble of bed linens, three items in three shop windows, one average price point: four thousand five hundred ninety-nine dollars. Wait. Here is an item for sale unpunctuated by a comma on its price tag: six-hundred-dollar pajamas. What the cost, the gridlock blare, this crushing hour, oh look maybe just twenty feet around the corner the sidewalk is nearly empty, therefore you look around.

It's pleasant to clamp your attention for a moment on that row of silent facades, those shoulder-to-shoulder sentinels ... no, those are townhouses or no are they called what? Spandrel, cartouche, quatrefoil, corbel, you can learn precise names of this block's architectural details any Sunday, thirty dollars for an hour of your time. Anne Bennett begins her walking tour noon on the dot. Her commute today on the M1 bus is like most Sunday mornings, uncrowded and on schedule, a peaceful interlude crossing 23rd Street, then up Madison. Behind her newspaper Anne Bennett is reading that ninety percent of the universe is unknown because that ninety percent is dark matter. The traffic light changes, the bus gains the momentum of an express while sixty-six letters of type nailing down ninety percent of the universe take hold of Anne Bennett, causing the always punctual tour guide to miss her bus stop and trotting all sweaty and distracted, there now she is not late and everything that matters has not been made inconsequential

by one sentence. She is not an idiot for devoting much of her life to the wonder of solid materials shaped by hands and tools in an expanding world of dark matter. No, not an idiot, proof is right there: she is pointing to a window cornice with oak leaves wreathed round clusters of grapes, anchored by a pineapple, a nimble collaboration of chisel and stone, the hand coaxing limestone into symbolic language: "The original residents," she explains, "delivered a message of hospitality in the pineapple adorning their residence, an expression of welcome, good cheer, human warmth and family affection inherent in such a gracious home." She continues the decoding: "Grape clusters. Here you have an element of birth-rebirth that furthermore emulates victory, as the ripe harvest shows the promise of fruits being reaped and turned into sustenance for the future …."

On script now, demonstrating to thirty customers how well spent is their money and after the tour, after an hour untroubled by reports on ninety percent of the universe, Anne Bennett is going to enjoy thirty-seven blocks of her city, walking all the way home, the news tossed in the trash on the corner of 57th Street is losing its grip with every step past brass door handles in the shape of seahorses, an oculus window deeply set, verdigris copper parapets three in a row.

The Sunday paper's dark-matter sentence creeps into Anne Bennett's bed, her sleep always so lively and populated with former boyfriends and formerly living people, her sleep now is a suffocating interval from which she startles awake. A sliver moon is visible through the skylight. The idea of sleeping under the stars in Manhattan had propelled Ted Channing to pry off a section of roof over the bedroom, to DIY glass and aluminum and caulk, lots of caulk sealed the glass-and-aluminum-framed skylight Ted Channing installed without a building permit. Famous in the neighborhood as a model of defiance of living under the radar of skirting the law,

depending on who you talked with in his era Ted Channing was a lowlife or a Renaissance-man polymath. He is a name etched on one glass pane of the skylight, one of thirty that comprise the opening to the sky. The longitude and latitude of the building defines the overhead view, a southwest patch of celestial mechanics, Saturn regularly moving left to right, an occasional streak of light, comet or falling star or starship, the astral view overlaid with the nearer movements of backyard pigeons leaving their droppings on the skylight. And that one lower-left pane of glass is hosting a human trace, though quite disappointed with how he has drawn the long looping cross of the *T*, first letter in his name, thinking how a thing is never as good as imagined, Ted Channing continues etching *e-d-C-h-a-n-n-i-n-g* and under his name MCMLXXXIII, the year in Roman numerals. A tricky operation manipulating four carats of diamond to behave like a pen shaping letters and numerals, he uses the bottom of the diamond, the *culet* it's called. This, plus another diamond, a ruby, two emeralds, a sapphire go with Ted Channing on his Air India flight to Madras, five gemstones moving through his GI tract. His reasons for swallowing them include a long-shot belief from the sixteenth century that in certain conditions gems have sex and procreate. Also, paranoia and fear and caution factor into ingesting and thereby hiding from view the wealth he is carrying. His reasons are many, the consequences are singular: the swallowed stones are lost in the urgency of illness, Ted Channing in the hospital unconscious of what's become of his gemstones, his system in the throes of a nameless disorder unresponsive to antibiotics, a rice-and-yogurt regime, the bedside ministrations of Kiran Chandoor, student nurse in the clinic in Madras, Tamil Nadu, India. What it must be like to be an American, she is wondering, sitting bedside with Ted Channing. Lingering there after her shift has ended gives Kiran something to think about, something other than bedpans and spoon-feeding and dirty linens and the twice-a-day hour-long bus ride, home-clinic-home. It's only late, usually around 8:00 PM,

that Carrie Clayton from Denver shows up. Carrie's relation to the patient is unclear, she seems not to mind that mostly Ted Channing is sleeping. "Let's book," she says. The two young women step out into Madras night. The American is all mouth to Kiran watching Carrie smoke a cigarette and drink brandy from a silver flask, words tumbling … "that's totally boss, kickass, dickweed, get real, lame, illin', mental, spazzing."

Also amazing: Carrie wants to be friends.

She's talking about someone named Theos Bernard, the subject of a thesis she's writing, "you know the whole East-West yoga thing, that's my research using Bernard, early practitioner, etc., etc., sort of you know using Bernard as an excuse, a ruse anyway, yoga's my passion. And your music, so flash." Kiran: "I know nothing about yoga but if you come to lunch tomorrow you can meet my father, he's chief music critic for the *Times*." Carrie: "Fucking A." Father, head of the household, chief music critic Mr. Chandoor, much too busy to be a guide to a visiting American, hands over his schedule of concerts for the coming days, week two of the annual Carnatic Music Festival. Actually, no. Head of the household, seated recipient of lunch, Mr. Chandoor is waving his hand, "send the Bearer to bring Miss Clayton's luggage. Dear young lady, as of this instant you, and I must insist, you are my guest." He waves his hand a second time, bringing into view two women carrying fresh tea and sweets. He bends his head over Carrie's portable tape player to hear not exactly music in a seven-minute jumble of guitar and from the next track on the mixtape, a woman is trying to sing, he can sort of make out *rock on gold dust woman take your silver spoon and dig your grave.*

ON A STREET

1988
COMPUTER ANIMATION
SPECTACOLOR LIGHTBOARD
MESSAGES TO THE PUBLIC
ONE TIMES SQUARE
THE PUBLIC ART FUND
NEW YORK, NEW YORK
MARCH 1–31

B I R D S

FLEE

IN

SUDDEN

HASTE

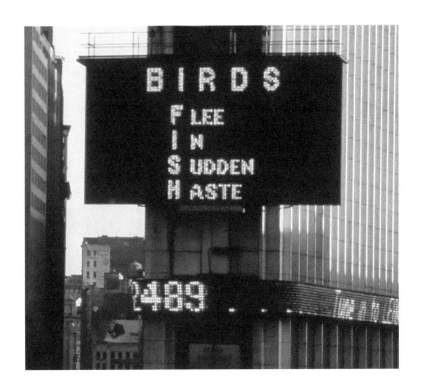

F I S H

 BRAVE

 ILLNESS

 RACING

 DOWN

 STREAM

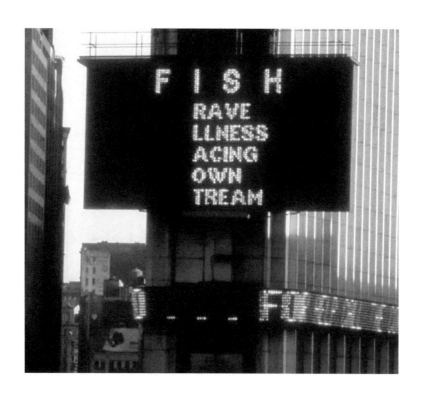

A N I M A L S

L A S A A T
L T K S A
U I T N
R N D
E G

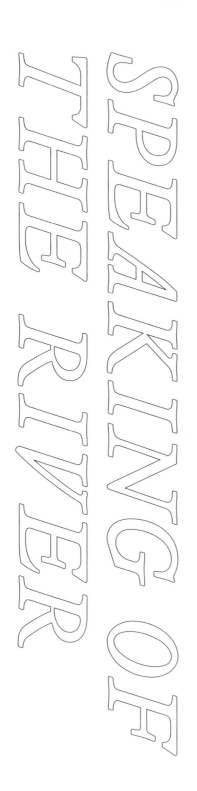

SPEAKING OF THE RIVER

1998–2000
SPOKEN TEXT AND AUDIO
INSTALLED ON SITE-SPECIFIC
SENSOR-ACTIVATED BENCHES
HUDSON RIVER, NEW YORK
RIVER THAMES, LONDON

HUDSON RIVER
MADAM BRETT PARK, NEW YORK

When you are not here nocturnal animals are in the open, somewhere
you are not. When you are not here a night bird stands sentinel in a tree.
When you are not here the number six is everywhere, every snowflake
formed of six points, six axes, the flakes falling to a depth of three feet,
very quiet when you are not here.

When you are not here the temperature has been minus twelve
degrees. When you are not here an ancient inland ocean deposited rock
sediment at this site. You sit on one thousand feet of bedrock, tilted and
folded and cut through by the creek—a story of geological turmoil in
the landscape. You sit near a ravine that was once steeper and sloping,
now worn away by use.

When you were not here a glacier was reshaping and carving the
creek bed. You sit by a unique kind of aquatic edge, a narrow run of
stream where the upper creek bed gradually rises to escape the influence
of Hudson River tides. When you are here and not here water invisibly
rises and moves with weather systems from continent to continent and,
more locally, from this small valley to bordering hills.

<div align="right">Spoken by CDJ, accompanied by birdsong. 3:33 min.</div>

That water is probably one half of what it used to be. Years ago that
river, that creek flowed steadily and harder than it does now. It was
a lot deeper. If you had a real real real high tide, with a full moon—
high tide, full moon—it would almost go up to Suckers Falls, a
hundred feet above the bridge looking up to the falls. Suckers are
fish.* My husband is a fisherman. So water has always been part of
his life and he just loves to go sit there and look at the water. Water
has a special meaning to us because it has a force. We believe a lot in
the power of water because water has the ability to cleanse and has
its own magic. There is peace and quiet down here. Peace and quiet.**
Almost a mystical feeling. The river is part of the family. It's here,

it's part of you.*** See the water rushing. Well, when you go over to Madam Brett Park … the sounds, the sounds. Water is so soothing, so calming. And I go there because it's peace, you know it represents peace. And I go there, I go, I go. Go down to the creek!**

Voices of three local residents (represented by *, **, ***) accompanied by water at different tides. Recorded and edited by CDJ. 1:49 min.

Not long ago archaeologists found a stone projectile, a record of prehistoric people living here. Very old maps from the seventeenth century record the arrival of European settlers in the area … French, Dutch, and British settlers, their family names affixed to land grants and land purchases along the creek and the river. August 8, 1683, a deed of sale was signed at Fishkill Landing by representatives of the Wappinger Indians and the purchaser, Frances Rombout, the father of Catheryna Brett—Madam Brett. Fishkill Creek and Madam Brett Park were part of the 1683 land purchase, eighty-five thousand acres of land. One hundred royales, one hundred pounds of gunpowder, two hundred fathom of white wampum, one hundred bars of lead, one hundred fathom of black wampum, thirty tobacco boxes, thirty guns, twenty blankets, forty hatchets, forty horns, forty shirts, forty pairs of stockings, forty earthen jugs, forty bottles, forty knives, four anchors of rum, ten half vats of beer, two hundred tobacco pipes, and eight pounds of tobacco are recorded on the bill of sale for this land, August 8, 1683. A 1689 map records a collection of Wappinger Indian dwellings located just where you are sitting, a site rich with fish and game in 1689, and abundant with trees. The Wappinger found no purpose for large-scale tree-cutting. They were using trees for fuel, bending saplings for shelters, digging out trunks for canoes. Not long ago a biological inventory of the park counted forty-three non-native species introduced since colonial times. Among the native trees still standing in the park: beech, sycamore, silver maple, red ash, eastern cottonwood, and hackberry.

Spoken by CDJ, accompanied by birds (titmice, wrens, chickadees). 2:46 min.

Shade and habitat and nutrition, these trees are temperate hardwood forest—oaks, maples, birches—a temperate hardwood forest with lowland evergreens of pine and hemlock. The trees are linked to a glacier, fourteen thousand years ago, an ice sheet two thousand feet thick. Warmer and warmer from arctic cold to the present, the climate grew warmer, the thick ice retreating, the tall trees taking root—oaks, maples, and birches with lowland evergreens of pine and hemlock, the long view of geological time visible in the present.

<div align="right">Spoken by CDJ, accompanied by birds of summer. 00:50 min.</div>

Yes, I'm local, I remember. The dust and the fabric were always flying because they were always doing something—spinning something in there. They made ladies' hats, felt hats. I even wore a felt hat at one time. We all wore hats then. Of course we had to wear hats in church at that time. A lot of people worked in the hat industry. This was the hat capital of the Northeast. Tiaronda Hat Works. In 1879 running at a hundred and twenty-five horsepower, the turbine wheel of Tiaronda Hat Works went into motion. Water becomes a hat. Water saves fossil fuel. Water cuts through rock. Water is a surface an insect can walk on. Water attracts the building of wigwams, cabins, mills. Water changes shape. One droplet attaches to one particle of dust in the high atmosphere and water becomes a snowflake. No two alike, though every snowflake is six-figured, always six-figured. Water condenses into a cloud, its lifespan approximately ten minutes. Drawn from the soil into plant roots and transported through the plant body, water evaporates from leaves into the air. Exhale. You are an ingredient in the process of transpiration, of water traveling through solids, becoming flakes of snow, clouds, the weather.

<div align="right">Spoken by local resident and CDJ, accompanied by creek-shore water. 2:20 min.</div>

<div align="center">

1998–99

PERMANENT INSTALLATION, COMMISSIONED BY MINETTA BROOK

11:45 MIN. EXCERPT OF 38:00 MIN., AUDIO MATERIAL ON BENCHES

</div>

RIVER THAMES
CANARY WHARF, LONDON

THE CALM DANGEROUS

3 That river's very quiet today.

5 I saw a very dangerous, very fast-flowing river.

3 Oh look, there's a liner.

5 Very dangerous.

3 That river's very quiet today. And it was. Very quiet. There was nothing there.

5 And you could see quite clearly that the water has a calming effect.

3 That's when it can be very cruel, very cruel.

5 Very relaxing.

3 I love watching the river, I could watch it for hours. It's so calming, very very calming. I spent half my life looking out my window because I had the most beautiful view. And I used to watch the boats, up and down, up and down. And some of them I could even tell the time by, they were that good. But now there's nothing.

5 You know I never saw, in my working day I never saw that romance. Getting to recognize the beauty of it. And that's tinged sometimes with a little sadness. Because you may see a new building going up or a new development near, but you

get a little pang in you because you can remember the grand you when your boat was tied up with your mates with the barges unloading. So that is still there. That will go.

3 My dining table was under my kitchen window. And there I sat. I'd get up in the morning and sit there for an hour, then I had to go to work. The minute I was back, the first thing I done when I walked in my flat was to look out the window.

5 That's tinged with a little sadness.

3 And it was. Very calming to watch river traffic, you know, it's so smooth. Plus you used to get a lot of birds, like cormorants came to the river.

5 Yes, it's a different world. Totally. Absolutely. People are nicer.

3 If I've got the raging nadges with me I'll sit on the riverfront and soon forget. Even though there's no traffic on the river now, there's something you can always watch.

5 So I never saw, in my working day I never saw that romance. I saw a very dangerous, very fast-flowing river that you wanted to have great respect for. And certainly wasn't thinking about rowing down with an umbrella up and things like that. It was a dangerous world out there. We lost many men out there.

3 Oh, I love watching the water. I imagine what's underneath it, try to imagine what life's under there, you know. I spent half my life looking out my window.

5 Now. Yes. It's a different world. People are nicer. Before.

> Speakers 3 and 5, recorded in separate conversations with CDJ, with music by Steven Vitello, 4:43 min.

RIPPLE

CDJ The river is a calendar and a clock, and the seasons and the hours come in colors and currents, light and angles. This is how the time is told. All through the year, the day, the moments, like this one, come in just this color, and this kind of light. And sometimes, the moment is in motion, time traveling on the surface.

3 When it's windy I used to like watching it because it used to ripple all the way along. You know, you could just watch it for miles rippling and think, *In about an hour's time that ripple will be up at London Bridge.* Yes. There's a ripple traveling and in an hour's time it will be up at London Bridge. And someone else will be looking at the ripple. Just travelin' and travelin'.

CDJ & 3 And someone else will be looking at the ripple.

> CDJ and Speaker 3, with shoreline water audio. 1:20 min.

WHEN

2 I came last year.

3 I've lived here since 1976, that's twenty-two years last month, I've been here twenty-two years.

2 Yeah, Somalia. I lived by the sea. Mogadishu seaport.

4 Yeah, I worked in the docks for twenty-three years. I was a docker. Loading mainly. In the Millwall Docks.

1 I came to England in 1996. In January. Eritrea, I'm from Eritrea.

3 I was told, actually when I came to view my property in '76 a lot of people did think it was a rough-and-ready area. Yeah. But I didn't find that, I did not find that at all.

4 I was born on the island, yeah. Marshfield Street. And I've lived there ever since. I would never leave this place, never. No, it's too interesting, this place.

2 Really it's part of my life because when you live near the Indian Ocean, you know, it's great really to have to live there. Because to hear the sound of sea, you feel very comforted to hear those things. I came last year.

3 If you're born within the sound of Bow Bells, then you are a true Cockney. If you can hear that bell, you're a Cockney.

1 I came to England in 1996. In January. Yes, I came directly to this area, to Mile End. I came with the children, my family is still there. In Eritrea.

<div align="right">Recorded and edited by CDJ. 2:20 min.</div>

SPEAKER 1 Sixteen-year-old Eritrean woman, recent immigrant to London's Mile End

SPEAKER 2 Twenty-year-old Somalian man, recent immigrant to the London Docklands, Isle of Dogs

SPEAKER 3 London-born woman, twenty-two-year resident of Isle of Dogs

SPEAKER 4 Seventy-year-old man, lifelong resident of Isle of Dogs, Fire Brigade volunteer, London Blitz, World War II

SPEAKER 5 Decades-long Docklands boat captain

<div align="right">

2000

COMMISSIONED BY PUBLIC ART DEVELOPMENT TRUST

8:23 MIN. EXCERPT OF 36:16 MIN.

</div>

SPEAKING OF THE RIVER

1994
SITE-SPECIFIC PERFORMANCE
SPOKEN TEXT, VIDEO, AND STILL IMAGES
ISABELLA STEWART GARDNER MUSEUM
BOSTON, MASSACHUSETTS
JANUARY 13 & 16

What a retreat inside these walls—the air centrally cooled and such order—organization is everywhere in the Metropolitan Museum. Take here, in the decorative arts rooms. Every piece of furniture, china, silver is in an arrangement; all the delicate icons in rows in sets in clusters.

On labels identifying each object, no one has indicated the eighteenth-century woman who sliced her meat with this silver knife, the people who penned their letters and paid their bills on this carved mahogany desk. Perhaps these objects began life as near neighbors—one noble tree and some dull lumps of ore from the same region of Brazil. There is still something of the forest and the dirt that clings to the desk, the knife. Something else is there, too: a point on the long arc from natural to domestic order, an echo resounding from men sweating and grunting, applying their ax and pick. Hush now, there is subtler work to be done. The silver now hammered, the mahogany now carved—there is furniture to polish, the table to lay, breakfast lunch dinner is served. A hundred, ten thousand times over, deft hands performed the same movements, the same surfaces retaining the touch of those who left lumpy beds at first light, so much work to be done. Perhaps in a bone-tired or just a clumsy moment, those dawn-risers, the caretaker or the housekeeper, perhaps they set the fire or spilled the milk that disturbed the harmony of the *great houses* they served. Through all the domestic dramas, major and minor, from rooms ablaze to glasses tumbling, only the objects have survived, passing from hand to hand to the last owners slicing with their knife, scribbling at their desk, their bones now buried in the dirt. And here above ground, in focused beams of light, their possessions have become evidence of long-dead artisans permanently displayed behind barriers of glass and velvet rope: "Cutlery, Revere, American ca. 1765. Writing desk, French, ca. 1730 (Charles Cressent)." And here each object emits a half-life, the room shot with particles of information, not a trace on the labels identifying these things before which we

oooh and aaah. Nearly overrun by a clutch of people arriving in a pouf of talcum and aftershave, jewelry jingling, I signal to the museum guide, move on without me, I am not of the group you are shepherding toward that soup tureen … a ceramic fantasy used for ferrying to the table Cook's secret recipe, her rich concoction with something of sorrel and crushed violets making waves through thick layers of cream. I am not an imagination ignited by the heat of the day, though damn, it is hot in New York City today.

I wouldn't mind being in the ever-uncrowded Gardner Museum, an institution Isabella Stewart Gardner determined would remain forever unlabeled, encouraging equal merit for all things. For the candy dish and the Rembrandt are equally regarded as members of her general population of things, albeit the collection is resting on her wealth and the attendant assets of privilege. And perhaps less obvious, less readily identified, is the element of her life that finds her in the company of Edward Sylvester Morse.

ISG Here I am, proof of any tattle you may hear. It's all true, oh, nothing is all true … but I am responsible for at least one true accusation, I do not follow the proprieties required of a Boston matron. Behaving properly and I would miss this opportunity, Professor Morse, to sit with you privately for a spell. Is there anything so intimate as a man and a woman alone in a carriage? Boston is so oppressively near and visible to us, but we remain invisible to Boston.

ESM I am always agreeable to being flattered by you. Though I rather think you have another reason for taking the time to meet me yourself at the station. •

ISG The professor is perceptive! I can't help myself, always I am itinerary-ing, I think of little else than my trip. I am relying on your assistance, you shall be my invisible, phantom guide in the East.

ESM I can help you, certainly for Japan I can. Most willingly, Mrs. G. ... no, another word. I am infinitely more than willing, though I am damned if I can remember a substitute word for my uncensored enthusiasm to help you.

ISG But no one can surpass you with words. I have been staying awake much too late and damaging my eyes for all I know. You are boundlessly generous to allow me a reading of chapters from your book in advance of publication, I feel quite like I have been chosen for a secret initiation. I am almost jealous of sharing you with others these next days.

ESM Shall we cancel my lectures, then? Shall we stay among ourselves, a small circle—of course Bigelow and the Fenollosas must be in the group. Your husband, Jack, perhaps?

So they talked on in the Gardners' carriage coming to stop inside the gates of home, Fenway Court, neither Morse nor Mrs. G. stepping down for much too long, the driver reported to his sister, who could not see any harm in it. Neither would Jack Gardner have minded, accustomed to Isabella's locutions. At this point in her meandering account of delivering their guest, the professor from Salem, Jack put aside his newspaper to catch that Morse had said, "How it will be in Japan, what we can expect and be on the lookout for. And Jack, how much I know now and shall benefit from his travels and studies, and his contacts too, look how I've written them all down. Morse has been generous with providing us personal introductions to his acquaintances in Kyoto and Tokyo, I don't expect we will be visiting the little villages he so loves."

Jack and Isabella departed in November 1883 with a forty-thousand-dollar letter of credit and twenty trunks of belongings, Japan, India, Thailand on their itinerary. Mrs. G. took charge of the letters of personal introduction provided by Morse, William Bigelow,

and Ernest Fenollosa, the circle of men whose studies of Buddhism and Eastern cultures have filled quite a number of published volumes and square feet at the Boston Museum of Fine Arts in the collections they supervised.

I have spotted evidence of Isabella Gardner's enthusiasm for Asian things in her collection, seen a string of amber beads under glass in her Early Italian Room, the beads identified in museum records as Chinese, nineteenth century. Upon counting one hundred and eight amber spheres, the count identifies the beads as a *mala*, a Buddhist rosary. If the museum records remain unchallenged, then the beads will always be labeled Chinese nineteenth-century strung beads, amber. Even mislabeled, unused, and preserved under glass, they will always be a *mala*.

Mrs. Gardner's 1895 purchase has the chance effect of rescuing the *mala* from the destructive imperative of Red Army brigades who eighty years later would have identified the *mala* as one of the Four Olds to be abolished during the Cultural Revolution. She has tucked into her masses of collected artworks a Tibetan Buddhist bell and a prayer wheel, small handheld objects of ritual, religious use—the beads, bell, and prayer wheel. Though on repetition, "beads, bell, and wheel" begin to sound like souvenirs one might buy in the Gardner Museum gift shop.

Imagine you are standing in the museum store or sipping ginger tea in the café. Imagine there is no floor. You are tumbling to a level below, falling in time to 1914. From small handheld objects, it is a sudden jolting step down to the ground floor, where statues over six feet in height dominate Isabella Stewart Gardner's Buddha Room.

Isabella communes, I expect, with worthy spirits in her secret room. Yet within those four walls I was beset upon by a kind of malevolence. Perhaps for an unknown reason I am receptive to wrathful sprits which I understand are members of the Eastern cosmology. I would expect to have been protected by or in near proximity to powers counteractive to anything malevolent. I am

speaking, of course, of the divine in each of us, the insight of Emanuel Swedenborg whose beliefs I share. For all my convictions, powerful forces among Isabella's figures and images struck at me fearfully. I am grateful for the experience; it is truly thrilling to be struck dumb with fear and made to struggle with a force not of nature, not of a living being nor of anything I care to confine by giving it a name.

—FROM THE LETTERS OF SARAH ORNE JEWETT, MARCH 10, 1910

I am downhearted for having been so disagreeable yesterday. Participating in debates and queries and discussions over years has habituated me to being overly concerned about our Boston Museum of Fine Arts. Presentation and verification—I have been too much—even in my unofficial position—with the difficult aim of finding some befitting manner to present our growing collection to the public. By such aims and standards your Buddha Room is rather a chaos. You have done a terrible thing. Bravo. There, I hope I am the first or at least among the first to give congratulations.

You must maintain the Buddha Room as your own solace. It is you or yours or however it might be properly expressed that while the collection of images and figures is remarkable in itself, the room is a treasure made by you. That is the terrible doing of all Fenway Court, and bravo, as ever I cheer your success.

Should any general or chosen public be welcomed to your Eastern-inspired room, then twice over will be the reward. Once for the collection and once more for being an assembly characteristic of and particular to only you, one for whom these things live and are living. Forgive my repetitious indulgences, I am so earnest in my deed to acknowledge today my understanding, having been yesterday all too judgmental, and to remain forever your devoted friend, Alice Fenollosa.

—ALICE FENOLLOSA, APRIL 22, 1910

ARTICLES OF FAITH

Stone and wood carved figures of Buddha can be calibrated in height, weight, materials, and, with the right optical instruments, will reveal the presence, if any, of sacred substances and relics sequestered within. People of Europe and the US have learned about the role of iconometry at work in Buddha figures, the system of attitudes and proportions that map a complex order of beliefs. And learning to recognize the iconography of a figure points the way to its particular identification as Medicine Buddha, Chenrezi, Avalokitsvara, Manjusri …

> If the meaning or content of symbols is forgotten or not known, one sees an art form or an ornament. Meanwhile the content of symbols is metaphysical or philosophical. It is not quite enough to use the terms of iconography freely and to be able to label our museum correctly. Identification tells us nothing of meaning.
> —ERNEST FENOLLOSA, 1908

Of ISG's Buddha Room, there is little left but a paper trail:

– A 1908 letter from W. S. Bigelow encourages Mrs. G. to purchase the large statues being sold by the Boston dealer Yamanaka. Bigelow includes photographs of the lot, estimated for sale at $100,000.

– An invoice to Mrs. G. from the Yamanaka gallery settles the $45,000 sale of the lot, including: three big Buddhas (Past, Present, and Future); standing Buddha with purple; seated gold Buddha; Kuannon; and two smaller ones. As in Bigelow's letter, there is mention that photographs of the lot are being sent.

– Several black-and-white photographs of the basement room during its existence from 1910 to 1963.

– Somewhere, perhaps, exists a stray memory notated by a now-unknown person given a private viewing of ISG's nonpublic Buddha Room, where, since 1970, museum guards change into their uniforms.

For a brief moment in their biography, six large Buddha figures resided in Mrs. Gardner's house, Fenway Court, in an area she kept off-limits from public visitors. Seen mostly by her inner circle, most of the Buddha Room objects sold at auction in April 1971 at Parke-Bernet, New York. End of paper trail.

NOTES

PP. 60 ISG *Here I am, proof of any tattle...* Conversation between Isabella
–61 Stewart Gardner and Edward Sylvester Morse written by CDJ, based on research conducted at the Isabella Stewart Gardner Museum library.

PP. 62 *Isabella communes, I expect...* and *I am downhearted for having been...*
–63 Letters written by CDJ, based on research into Sarah Orne Jewett and Alice Fenollosa.

ARTICLES OF FAITH

IN A CAR

2015
SPOKEN TEXT AND SOUND MATERIAL
INSTALLED ON VINTAGE RADIO
PERFORMED LIVE, 16:15 MIN.

Of twelve respondents for the job of driving a BMW from New York to San Francisco, you are the chosen one.

Here we go, a road trip under American sky, you're thinking. You want to stand there, lone figure out in the open. For a while it's all about hurry, hence about numbers: twenty hours divided into three more or less eight-hour segments of driving, four gas-tank fill-ups, a million iced coffees across one thousand four hundred and eighty-five miles, a road trip under American sky you're still thinking, standing now in Nebraska.

Standing, sitting, lying down … of three possible positions you've no memory of hitting the ground. A couple things are coming to mind: you took a few steps from the car, you looked up, few steps from the BMW, head tilted up. Sky is you is everything is down.

Felled by enormity, apparently. Horizontal on what to call this—plain, pasture, prairie—left, right, and probably behind you it's flat to invisibility. Actually, things in the nightsky are better seen from this position, flat on the ground. At least the alien enormity, the vertigo-inducing nightsky, at least that incoherent light-sweep overhead is taking on shape and definition, becoming … you can do this, you went to school … becoming Orion, and that's Sirius, and uh and Polaris. There. The sky is *not* incoherent, we have plotted orbits and given names to celestial objects, more and more of the universe coming under the scrutiny of better and better lenses and, back in the car, the dashboard GPS sets you on track: US Highway 47, two-lane and straight, merges onto Route 80, you and trucks, almost nothing but trucks at this hour, says Joe McGuiness at the rest stop over a plate of french fries. He is explaining what you thought was urban myth: his truck is in constant motion, its thirty-foot container holding industrial waste unfit for any landfill. Perpetual shepherding of effluents from pest control, lawn care,

pharmaceuticals is a line of work with constant turnover, so a job is always there. "My daughter goes to college on my savings, thank you very much, and my ancient grandmother has it nice in one of South Carolina's best geriatric facilities."

At the next truck stop, a woman driver in the male sea, of course she stands out, Jenny of the haunted eyes tells you: "That's right, been doing this a long time, a while anyway. What? Yeah, I'm licensed out of Pennsylvania. There's a couple women in our outfit. Three, actually. See, it's an accident really. I mean I read or heard, can't remember. Anyway there's a guy. And the guy, he kicks heroin cold turkey on a cross-country Greyhound. For me, big lightbulb goes off, big. I get on a cross-country bus, kick my habit, and it's more or less what I'm doing ever since, kind of a P.S. on the Greyhound if you get my meaning. Point being as long as I'm driving, I'm clean. Total lifesaver, my rig. Course, I got a soft spot for users that cleaned up, you're probably too young to ever heard of Jimmy Page or Marianne Faithfull, you know, who I listen to in the rig, my music."

Five hundred and sixty-seven miles later you swap out certain details: Jenny's truck becomes your BMW; her name is now yours; her-now-your demon heroin life, stark and terrible, is the traveler small talk you make to an audience of itinerant retirees in South Dakota. Like a choir the retirees say *Jesus forgives you Jenny*, though actually you've made this side trip to South Dakota for the nonreligious, cocksucker-sprinkled *Deadwood* series you binged on during a week of bronchitis and, OK, your mother's addiction is South Dakota Black Hills gold rings and bracelets sold on QVC, that's another reason you're in the middle of nowhere waiting out a rainstorm at a roadside diner. A collection point for retirees apparently—one calls out to you, "Jenny, take a load off, pull up a chair," their circular table littered with cups of coffee and crumbs, and pieces of fake gold laminated in the tabletop say: *This Is South Dakota*. The traveling

retirees got here on the same map: following thirty responsible years on the job house mortgage two kids and now lovely purposeless days of driving. Their vans and SUVs converge on sites known as geocaches. You learn these elders of the road scorn official state and national landmarks. You learn a geocache is a landmark of one's own designation, a rogue undertaking. This is how: sign your name the date and time of landmarking this particular tree or rock or deep crevice now identified with James Olivera, Melinda Gregor, Christina Freeman, Max Gray, four retirees at the circular table are examining each other's geocache journals of self-declared landmarks, impressive listings going on for pages. You start to eat like they eat, french fries and pancakes washed down with weak coffee. The chatty forgiving retirees, "Bye-bye Jenny," they're calling after you in your weak-coffee-and-carb stupor. *Hold on I'm coming* you sing out loud to keep awake in the car. You've clocked over six hundred miles, it's late, so dark. The BMW owner didn't say anything about not sleeping in his car. Just, "I don't want you smoking and stinking up my leather interior." Oh my. Saddle-colored animal skin upholstering his chariot. All night asleep in the back seat, your nose up against the smell of leather, and living animals are grazing nearby, you see that now in daylight, you see horses. A woman walks out of light. Leading a huge shiny black mare, she comes right to the point, her name is Linda; the horse is named Dolly; this is private property. "However," she says, "you look like you could use a proper washup and a spot of breakfast."

The GPS shows you're in Wyoming, very eastern Wyoming, only a hundred or so miles across the state border. The clock here is Linda and her horses timed to long stretches of nothing. Staring at the ground, staring straight ahead, maybe these are not stretches of nothing to the woman and the animals occasionally breaking the spell to eat something, to drink. Water for the horses, for Linda a bottle of bourbon is on the windowsill over the kitchen sink, its level going down in the course of the day.

IN A CAR

Up wash eat work wash eat sleep is day one. Day two, day three are the same day all over—up wash eat work wash eat sleep. Linda doesn't blink at you sleeping in her barn and trailing around doing the pony brushing and hay changing and helping get fifteen big thoroughbreds in and out of the barn. Three days on the horses' planet, their circadian is our up drink eat work, maybe enough of that.

Slipping into Linda skin, her loping walk and lilty voice make it so easy to shed the tense-shoulder fried-voice former-addict Jenny person that's been you for these Wyoming days. You love being straight-to-the-point Linda: "Not every horse-loving woman is a cliché about liking to have something big between her legs," you say to the folks in Oklahoma pulled up for the night at a cabin motel, no one all that interested in hearing you/Linda talk about how you're driving to Santa Ana, your prize two-year-old running next week on her four-for-six streak. The center of attention is Carol, license plate Maryland, her car stuffed with fake geodes and astral rocks, her tools for reading a person, laid out now on a blanket. Each traveler hands her their rock of choice:

"Wow, sorry, really not professional dropping your stone like that, your heat all over it … which tells me, yes, you'll find an outlet for your potential." The next traveler will be loved for being so caring. Next will be contemplating a change of residence; next will be rid of pain, next will reunite with a lost friend. Every traveler deserves to be told something more compelling and personal, even startling, you're thinking. You could deliver that, be a better Carol by the next time zone. As usual, travelers huddle in the motel parking lot, swapping road tips and episodes from their lives and less interested in the rock-reading Carol person you've become, less interested in geode revelations than in grass-fed steaks on a grill Brenda, license plate California, carts around in her converted food truck.

Her steaks are amazing, the rest of her meal better than good. Her mobile life as a foodie without a permanent address, you could so do that, be Brenda you're thinking, recalling Mother's card file of recipes. Meatloaf coleslaw summer pudding menus start coming to mind crowded out by a tire-squealing bus tilting into the motel parking lot, it unloads band members in the middle of their first cross-country tour, they say. A sorry bunch, raggedy and fighting, four of them out-quarreled by the tall screaming one you learn he's the singer. He's going to peel off from the group and get the hell home to Queens, four blocks from your address. Four blocks from your address. How is that possible here in Utah?

Also from the blue: a message from the BMW owner requests you deliver the car to an address in Los Angeles, more pay for the extra day of driving is indicated. Good. Excellent. Because already you are over the contracted number of days to complete the job and for good reason, you could explain in short order even if it's a long windy lot of episodes ending in the absolute truth: you've had it with driving. You pocket your salary plus bonus, a slightly different person than seven days ago—five pounds lighter in weight, also having shed the last of your traveling selves—Brenda for Carol for Linda for Jenny for your name on the plane ticket home. In your seat's upright position, you're thinking a stable core self is overrated, same for a road trip. Or maybe you can monetize your journey, write and sell your story, one of those travels-with-me articles, definitely you're doing that tomorrow, you're thinking, I love tomorrow.

2019
SPOKEN TEXT, AUDIO, VIDEO
15-INCH SENSOR-ACTIVATED DIGITAL FRAME, 3:00 MIN.

The hawks, red-tailed and silent, the hawks come in twos, sometimes three come into view. The eagle always comes alone. Yesterday, that lone predator came gliding closer and closer, hovering just there, white of head, black of eye, wings of the window's width. That will never repeat, that eagle in close-up. Always that creature is out there. Comes the foghorn aria and the lonesome whistle blows. They're out there—invisible ship on the water, invisible train barreling north. Radio Three Fourteen is out there, transmitting in a bandwidth surveilled by Stellar Wind government programs. Space mission Voyager 2 is out there, transmitting data of the space between stars. Comes the ghost echo of yesterday's Earth-based transmission, reporting "The trial of Paul Manafort was a spectacle of small humiliations." Hmm. His deal-maker millions laundered in offshore accounts, his decades-long parade of swindles, downsized in the news to "small humiliations." Already taking up less oxygen, fading and so barely out there you don't even remember, you never heard of him, the confidence man on trial this unusually wet month. Rain used to be hydrogen 2, oxygen 1, oh we're not yearning for some yesteryear this unusually wet August 2019, 2020, 2021 … Every time since the year 14, every time we say "August" we evoke Augustus, Augustus Caesar, the one-man government who replaces a republic.

BEDSIDE

2017–18
SPOKEN TEXT AND SOUND MATERIAL
INSTALLED ON VINTAGE RADIO
PERFORMED LIVE, 3:46 MIN.
TRANSCRIPTION ON DIGITAL PRINT, 45 ¾ X 12 ¼ IN.

Some nights next to your bed a candle is burning. Midnight one o'clock two, still awake, now it's three in the morning—hour of the wolf of the devil the witching hour.

Wolf devil witch. You don't believe in them, even though your brain at this hour is not its usual fortress. And the ceiling over your wide staring eyes is hosting those specters of old—wolf devil witch—released from the flickering candle next to your bed. No, no, they're not coming to get you, they're not what's keeping you awake.

Twelve hours earlier on the floor of the New York Stock Exchange the last hour of trading earns its name, *the witching hour of high volatility*, three PM posting figures with decimals, fractions, small numbers you know represent dollars in the millions attached to actual people walking this same earth as you. Like the banker man with 41 million dollars of performance-based equity reward on top of a 2.8 million base salary on top of 5.2 million in shares, equaling 49 million dollars: one year of one banker's income.

Like some nonstandard standard of living: There's one banker and his 49 million dollars at *the witching hour of high volatility*. There's you and your tiny circumference of food clothing shelter cinched up tight in bed at this hour, going on four in the morning. A bad rumble is nearing, a dread huffing on your heels … on a wide boulevard in a part of the city, gray and broken, a labyrinth of streets says everything depends on getting out of here left right you're making mistakes with men a cluster of men a conspiring cluster huffing on your heels the way out is left right is somewhere ahead of you the hunted the designated prey in a sweat, blood pounding, you make it back to your pillow. Four twenty-seven PM, no no you're not going back to sleep, back to that place called the mystery of our double existence in the dark by Elizabeth Bisland. There she is among many who are a pile of books next to your bed; Elizabeth Bisland, on dreaming, page 37:

... night after night, with calm incuriousness we open the door onto that ghostly underworld, hold insane revels with fantastic specters, weep burning tears for empty griefs, babble with foolish laughter at witless jests, stain our souls with useless crime, and with morning, saunter serenely back from these wild adventures into the warm precincts of the cheerful day, unmoved, unstartled, and forgetting.

Close the book, blow out the candle, five going on six whatever the hour, you're not forgetting.

Not forgetting the Wells Fargo banker with his 49 million.
Not forgetting his brethren bankers at Barclays, J. P. Morgan, Chase, HSBC, Deutsche Bank, and more recently you read that Equifax chairman Richard Smith will retain about 18.4 million in pension benefits, shares worth 23.6 million, and bonuses of 3 million dollars in 2015 and 2016, though Mr. Richard Smith agreed to waive any bonus for this year, 2017, the year of the Equifax hack.

BEDSIDE

2018
SPOKEN TEXT, AUDIO, VIDEO
12-INCH SENSOR-ACTIVATED DIGITAL FRAME, 3:07 MIN.

On the last night of a four-day weekend in a cabin in the woods
without electricity—the firewood's running out, dripped away,
all but our last candle dripped away. Not much going on now the
wind's no longer blowing, the woods no longer drip with rain,
no electricity's delivering sounds and light. In near darkness and
silence is where we are.

Going on eleven at the candlelight table, wick and wax and fire
conspire to become currents ascending descending gravity capillary
action trails of smoke particles of soot … a lot's going on. Maybe of
little, of no interest to you there in the same room in some distant
moment, some event at the end of your many-yard stare. Sitting
across the table we're in separate realms, summoned by a bit of
combustion in the dark. The candle's flame is generative; I can see
that, see the flame casting shadows on the wall. I see January April
November. The flame is wavering the air with *life is just a party and
parties aren't meant to last*; with *I'm leaving the table, I'm out of the
game*; with *don't believe for just one second I'm forgetting you,
I'm trying to, I'm dying to, I'm falling down.*

That's Bowie gone last January and Leonard Cohen in November
and Prince in April, three of many, many are the losses in a year.
Woes cluster, rare are solitary woes. Many are the losses in a year fast
becoming twenty, twenty-three months ago in the here of my quiet.
A last candle's wick and wax and fire waver the air with a repeating
refrain, Edward Young's centuries-old lament frequently haunting
the moment with: woes cluster, rare are solitary woes. They love a
train, they tread each other's heel.

1999–2000
PERFORMANCE
SPOKEN TEXT, AUDIO, VIDEO
60:00 MIN.
PRODUCED AT THREAD WAXING SPACE
NEW YORK, NEW YORK, 2001

For days I had been plagued by certain images and sounds, very intrusive, the way a shard of a dream pokes into a waking moment. A lot of dream remains just beyond, unlit and elusive. It was like that.

Again and again the splinter of a scene flicked on, flicked off. This seemed to happen only when I was wearing a particular coat, newly acquired. Believe it, don't believe. An object contains the information of all it has come into contact with, much like a diary or a file of events.

Not everyone can read the event-file of an object. One who can do that is called a scryer. Perhaps scrying is no more or less mysterious than reading, than transforming small black marks into words and meaning.

Reading is not magic. Neither I think is scrying. I became a scryer by accident, by acquiring a coat. It was hanging on an iron fence in my neighborhood, appearing to be a figure leaning against the high railing. Maybe a man, maybe impaled there. Last week the news carried a story of just such a fence-impaling.

On this day the news was made of warnings and instructions. *Stay indoors. Collect candles and batteries. Stay off the 911 line. The snow, the snow*, reporters chanted. Twenty to twenty-five inches predicted, a foot plus already on the ground, I went out walking. The drama of the news stream drew me to the form hanging on the fence. I rescued the coat and returned to my apartment.

It, the coat, gave off steam but no bad odors as it dried on a radiator, a radiator that went cold that night and stayed cold. Another long weekend without heat, the whim of my satanic landlord disguised as blizzard cause-and-effect. The dormant boiler in the basement, the steady snowfall, inside outside, very cold, very quiet.

Skin next to silk next to cotton, then wool. I sat layered up in a zone of oven-warmed air, the new coat dry and black and one hundred percent wool draped around my shoulders. My first vision was of a torrent—not of rain or falling snow, but of words and birds and body parts mixed together. The second time was a tumble of plus and minus signs.

Little by little, though now it's so obvious, I concluded: the coat was the source. Discarded on the floor it was just a pile of cloth and buttons. On my body it provoked recurring visions and sounds that became more cinematic as time went by, more like a splatter film. Severed hand. The sound of metal crunching. Knife. Exploding door.

Splintering glass and blood spurts and decapitations and thunderclaps—these did not seem clichés off the screen and happening all around me. Achoo. I was scrying. The coat's former owner had a bad cold. And I experienced other unpleasant characteristics of that person: lower back pain, nail-biting, fat-fried food lingering on the taste buds.

Believe it, don't believe. An organ recipient leaves the hospital craving whiskey and a cigarette, the daily habits of the organ donor at work in the second body. The coat was doing its work.

Persistently a voice-face-person was attaching her-his-their self to the surrounding spurts and storms and splinterings.

Persistently, near and nearer.

I went to the laptop on my desk, needing to fix this persistence with an identity, a name. Like any touch typist, at the keyboard I am a kind of automaton, the fingers a conduit that completes a circuit of physical mechanical electrical impulses tapping away.

Conduit, conductor, feedback round the clock, tap tap tick tock. Message boards blink with the postings of wandering souls. A wandering soul is no less real than you. Proof is on the way. Two visitors, they're coming, two from a long procession of the living and the dead. Conduit, conductor, computer tap into the lives of Mary Shelley and Nikola Tesla. They're together now, those two, Shelley and Tesla together somewhere we are not.

Sorry for the glitch, I'm used to that happening, some unnamed mischief between frequencies.

Here will come Mary Shelley, always first to arrive:

"My thoughts were more fantastic and agreeable than my writings. I kept them to myself, the suggestions of my mind. They never saw print, except once. Just once I let others enter my thoughts— my creature, my Dr. Frankenstein and all the members of that tale I'm remembered for.

At the time, as always, my head was a house for my ideas to haunt. I was content to dwell in there alone. Well, not really alone. I did have the dearest companion, a man made of light. It is a fact he was no less intense than the actual people in my life. I enjoyed his friendship, his company always with me, even though he did not yet exist anywhere else. That all came later when he was born of a mother and walked the earth as Nikola Tesla. Now his name belongs to the Tesla coil, the development of AC electrical flow, over 1,700 patents …

Dear Niko. You come when you can, darling. I know this is not your idea of how to behave in public. Formal, that's Nikola's way, everything very formal. How do you do. My name is Mary Shelley."

Ah, as you can hear. Another noisy glitch that is certainly Tesla making his entrance, a bit overcharged, talking:

"Oh, once I was like you, enveloped in a skin. Though outwardly, my true self was forever migrating outward. Now my journey knows no bounds. Inward, outward—what are these but words. Everything is waves, currents moving in patterns below most radar, but not below ours, Mary's and mine. Mary had to learn the patterns, so new to her, not so to me. A watch ticking three rooms away, thunderclaps five hundred and fifty miles away, always I heard through walls and across miles. A fly landing on a table caused a thud in my ear. The ground under my feet trembled continuously. When I was in Budapest … but never mind. In my life the most interesting places I traveled to had no names, no city limits. Night after night, wide awake, I traveled to such places, seeing the sights and making friends. Those experiences were a prelude to where and how I am now … nameless, boundless, nevertheless existing."

MS Niko. I have not completely forgotten clock-driven days, it's a language I once spoke, a place I once visited before there was now there is nothing but now. To run, to eat, to sleep, we do none of these things and miss none of them either, not really.

NT Miss them! Birth, growth, old age and death of an individual, family, race, or nation, what is it all but a rhythm.

MS Gone the blood, flesh, fluids. Gone Mother's death, Mother's death, Mother's death made an outcast of me, a creature whose very life caused the blood-soaked deathbed of another. Beds, ha! I do not miss the great burden of the body ... you bring that all back to me, all the noise emanating from you out there just now is a great jangle to me, a room-filling clang of colliding tones and pitches: your twisted tendon, your bloody hangnail, headache, your tongue nursing that tooth ... all as present as air. Except. I can choose not to breathe your desire for tomorrow. I have that over you.

NT Resistor, equalizer, inductor, transformer, receiver, amplifier, passive components misbehave, yes we do. Bring up the power very slowly and carefully, up and up and up very gradually stimulated, yes impulses jump, sender to receiver. Mary, be the frequency of me.

ME Pardon. Last night you said something that made me think. Here let me read, I wrote down what I was thinking: both of you share an interest in automatons, you both evolved complex

notions about them. You first, Mary Shelley. Your interest was informed by scientific thought contemporary to you; there was in circulation a notion that the body had an interaction with electricity. Galvani's experiments were crucial; he wired frogs and other freshly dead creatures, made them jump and twitch. The conclusion, considered by you and contemporaries, was: galvanizing the body could be a way of regulating it like a machine. The body as conceived by and potentially controlled by science is a dilemma you see and dread. Tesla, you on the other hand embrace the body electric with no dilemma, saying: "I have by every thought and every act of mine, demonstrated and do so daily to my absolute satisfaction that I am an automaton endowed with powers of movement which are merely responding to external stimuli beating upon my sense organs, and the being thinks and acts and moves accordingly."

And so, Mary? Niko? So, I was thinking how you, Niko, developed a remote-control mechanism that regulated and controlled a model ship, that was 1898 I think, and you proposed that such full-scale ships and machines, remotely controlled, would be the end of all wars. Whereas for you, Mary, your concern remains the war of ideas, wars of science on the human body, in a word on life and death …

MS & NT Just keep typing, take this down.

NT A picture becomes a motor. First, I build it in my imagination, make improvements and see no fault anywhere. I put into concrete form this finished product of my brain. And the experiment comes out exactly as I planned it. In twenty years there occurs not a single exception. Why should it be otherwise? When I think of them now, my motors and coils and transmitters and patents, when compared to my entire vast systems, they

are small and trivial. They are like Hertz and his bandwidth, Marconi and his wireless, one name attached to one insight: that is what engraves the world's memory. Where is my reckoning? I knew the society of the future … just as you see me now in this vast system, remote and wireless. I saw that in 1899. 1899! "Attach our engines to the wheelworks of the universe! All notions of distance must vanish!" "Alive! The earth is alive with electrical vibrations, I make them visible, I make them sing and dance." "Immense electrical activity is two coils oscillating in resonance; through resonance, energy almost without limit is free for the asking. Free!" 1899 and no one was listening. I believed the future would judge me fairly. But what do you say of me? Barely a word, even my name is not your familiar. Edison Edison Edison, him you remember; a man without a method, a simple inventor and businessman. Never mind. Money to build my visions, to live in a sender-receiver matrix, extending, extend-ing—cash currency is the one thing my mind could not produce. Here is my mantra: there is nothing in the pocket that was not first in the head. Give me the money.

MS I am tired of the ashes-to-ashes, dust-to-dust myth. The tedious dualities separating being alive/being dead, making believe death is an eternity, prolonged and unvarying. I am not so trapped as that. So please, I ask all of you, please stop. Pick over me no more, adding words to my words, rescripting the story I lived, I wrote. That one story! As if I am ever eighteen years old with my head on a pillow, night after night, the rain drumming on my window, my husband roaming the house raving through opium-saturated hours … the year is 1816, yes I was young, yes I wrote *Frankenstein*. But what of the year 2073? My book *The Last Man* opens in the year 2073; a time of terrible plague, the decimation of humankind. *The Last Man* foretells your present, though none of you recognize that book of mine, dwelling as you

do on one book only. Simply stop, leave it be. So much more to being alive, being dead. You sitting there exhaling the fumes of yesterdays that were good, yesterdays that were bad, I want you to remember what I told you: I can choose not to breathe your desire for tomorrow, I have that over you.

I typed their laments. English in my ears out my fingers very fast it didn't take much to get Shelley and Tesla going. When they're in my presence and want to speak without me understanding, they use this private language you're seeing:

And this:

This image I imagine to be the villa in Italy where Mary Shelley wrote *Frankenstein*. The year is 1816, June, not the climate she hoped for her summer. And regularly from the upper-right bedroom window, she watched the lightning flashing on off on off; the landscape made visible in the dark was a picture of flesh, electrically reanimated, coming into focus.

This image I imagine to be the building that dominated the landscape where Nikola Tesla grew up: Croatia, 1856. He was born to be a member of the clergy, a Serbian Orthodox priest, and to live in a grand edifice like this one. Joining the clergy was his father's idea, a plan that oppressed the little boy who communicated with animals and experienced luminous phenomena, shimmering images that he learned to banish but never gaining control over the intense light flashes he experienced throughout life.

Ah. As you see … the return of Shelley and Tesla's private language.

How I wish I could share with you a translation a deciphering after
many hours of effort, hours alone chasing down their I-don't-know.
Maybe their pillow talk, maybe their only-for-two speak, their *be
the frequency of me, be the frequency of me*, sounds of love, maybe of
sex after death. I don't know: that's my lament—to not know for all
my hours of effort at night at my laptop tap tap tick tock. Believe
me I could bore you with all I've learned from and about Shelley and
Tesla. Shelley's creature reanimated from dead bodies is our genetic
engineering. Tesla's remote control and wireless vision is our device-
linked internet.

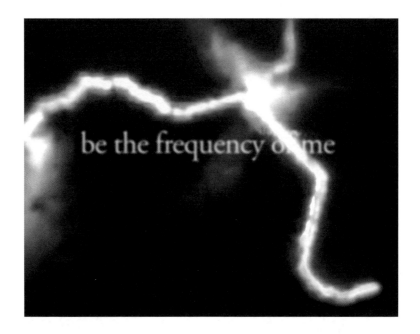

be the frequency of me

MS & NT As you say, tap tap tick tock. Take this down. Last words for
tonight:

NT Picture the earth as the one true natural resource. I alone under-
stand how to tap its latent power. Coils the size of a room, that
is my solution, that is what I had to build—a kind of pump to
draw electricity from the earth, great sparking discharges. This
is how I close filthy mines and stop the spurting black gold, an
end to all that is crude and wasteful that is coal and oil. I make
the earth oscillate as if it were a laboratory apparatus. And
what filled my thoughts as I worked in my high-voltage room?
Just this: the transformation of the entire globe into a sentient
being that can feel in all its parts and through which thought
may be flashed as through a brain. This is how peace will come,
through my idea Project Pax, peace in flashes of government
intelligence telemessaged through the earth.

MS The earth, it seems very remote, another sphere. I roam there,
though not as you might imagine. Human vanity presumes
the dead always visit a living human. I prefer spaces between or
within matter. Quite often I will inhabit something ordinary,
say a vase so cherished that it was stolen by a lonely man to
sit on one of many glass shelves he lined with his porcelains,
much coveted and fought over and causing two brothers to stop
speaking for seventeen years. Once, a clock gave me access to
the room where Tesla pored over his books. He stopped winding
the mechanism, wanting its racket to end. I, too, loved sitting
there in the silent room, the pages of his books softly rustling.

JEWELRY

2015
SPOKEN TEXT AND SOUND MATERIAL
INSTALLED ON VINTAGE RADIO
PERFORMED LIVE, 7:53 MIN.

My blackout ends with golden things inches from my eyes. A small-caliber bullet, boxing gloves, three names spelled out in diamond-accented gold script, and two obscure symbols introduce my hospital orderly, Charles Baker, his autobiography dangling from his neck. My fascination with his charms on a chain brings Charles to my bedside at the end of his shift, talking a husky streak accompanied by the soft clunk of gold against gold. Stories, a rush of stories hazed by my morphine drip is a tangle I take home from the hospital. A few details endure—Charles was a Golden Gloves champion, bantamweight; his firstborn is deaf.

An old memory comes to mind: things dangling from our necks are thought to be the first jewelry, some forty thousand years back. Pure decoration embellishing the body, that's one function of those ornaments. And infused with symbolic meanings, those same ornaments communicate the wearer's station in life, the elevated value bestowed on certain metals … as has been the way with jewelry into the present.

Today an ad in the *New York Times* pictures a $450,000 emerald-cut diamond solitaire ring with the added value of provenance: the ring once belonged to "wealthy philanthropist Eleanor Ashcroft." Its migration from Mrs. Ashcroft's finger to a public auction is jewelry's often-repeated journey initiated by death or changes in fashion or the economic downturn of the owner. A frequent stop on the itinerary of an object separated from its owner is the thrift store, the junk shop, its display cases burdened with masses of pre-owned jewelry. Such a trail of unrecorded human events resides in all those bits of metal and colored stones organized into rings bracelets necklaces brooches—the biography of each object lengthened as it's inherited or resold or donated.

We know this; we know the life of jewelry is long.

And, too, jewelry is made for losing. No one can say that isn't so.

Your case in point may be earrings left on a public bathroom sink. And in any group of five or more people, someone is likely to have experienced the high-emotion loss of their most singular love token. Our engagement rings and wedding bands gone missing insinuate: this relationship is not meant to be, this marriage is doomed. From afar the lost token transmits its disturbing message.

The sudden gone of a thing is a haunting—the vanished ring bracelet necklace gone to the place where lost things go, our lost things falling falling, I wish I had a map to the place where lost things land.

Where are the finders? Won't you step forward, you who found my grandmother's pearls on Houston Street and you who discovered my cousin Dolores's ring at Orly Airport. Her substantial pink diamond set in platinum inherited from our great-aunt left Dolores's finger when she pulled off her glove. Pearls that every Sunday circled a neck from morning church until bedtime, a ring never taken off, that skin-close contact continues to inhabit the thing, the body-to-object commiseration lingering in the subatomic realm. Called thermodynamics, if you like. Or call it nonsense, if you insist there can be no vestigial intimacy lingering in the ring or in pearls separated from their owner.

A friend insists the brooch she wears, a Maltese cross, once belonged to Coco Chanel, and furthermore, in a previous life it belonged to Grand Duke Dmitri, grandson of Tsar Alexander II, first cousin of Nicholas II, a successor to a band of Christian monks, the Order of St. John of Jerusalem, who chose the original cross as their insignia.

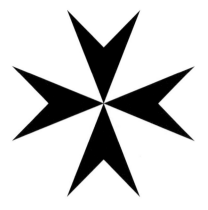

1432: The Order's mission, to provide for visiting pilgrims, takes on a military identity as of necessity the monks become crusaders in Jerusalem, knights fighting for possession of the Holy Land.
1530: The home convent moves to Malta and stays for three centuries until Napoleon disperses them; a large number of refugee knights find shelter in St. Petersburg, becoming a pan-Christian order with hereditary rights, known as the Russian Grand Priory.
1917: Dispersed by the revolution, a circle of Russian exiles in Paris reorganize the Russian Grand Priory once they have obtained food and shelter and acclimated to Parisian ways, retaining the original monk's cross to designate the brotherhood. In 1927 Coco says: I accept the medal, Dmitri's insignia intended for sons in succession who have lost their place in the tidy network of royals. Ha! I could be honored in their nation's revolution—the little worker who earns a place in the social system. I know the language, I know the premise: the individual and the social collective are the same. Lenin need not lecture me. Dmitri is lovely good company, I do not swoon over his title, I like it but I do not swoon. Pleasantly dull and so wonderfully undemanding, this well-preserved man always in a state of repose wraps his long fingers around his glass of tea, the same fingers that murdered Rasputin. He gives me jewelry.

2013
SPOKEN WORD AND VIDEO PERFORMANCE
52:00 MIN.
BOOK PUBLISHED BY BUREAU, NEW YORK

A chair can be a sad thing.

At the home of Henry Brooks, a chair is the size of his universe. With one of his legs not working, everything shriveled and wrinkled, Mr. Brooks sits and eats and sleeps and takes his medicine and I provide some company.

I come in the name of the ministering saints, we who volunteer as Compassionate Companions. We receive our training at Holy Cross on Grand Street. A Compassionate Companion is prepared to do laundry, to run errands, to sit quietly or accompany the elderly person to an appointment.

My duties have been simplified at Mr. Brooks's request. I read to him, books fetched from his dusty study. Today's selection is someone named Oscar Wilde: *One candle of light. The horror of it. The foul parody. The face in the portrait grown hideous. Grown? The inner sin eating at the face. God we must pray. Stab, stab, stab, he stabbed him twice more but*

After a while I am reading to the air. Mr. Brooks dozes medicated in his chair and I snoop, I cannot help myself. I am searching for him among his mementos, everywhere a large life dwindled now to the chair-size universe. Burning curiosity, I know that's no excuse, I find every reason to open drawers, how they slide with never a hitch. Comfort is that quiet slide. You think you know comfort, then you take a train from the Lower East Side and come to an apartment like this. If this is a couch, then what have I been sitting on all my life? I remember thinking that.

I know about memory and the mind from watching the Science Channel on television after my husband drops off and I can relax. I detest his sports men yakking and yakking until I can click the remote. There now, someone is icing a cake, someone is explaining evolution, I always liked science, now that's a really pretty bracelet she's demonstrating … "*It's practical, it's cute, really cute. Every single piece cut by hand. An unbelievable price. Unbelievable. Two and seven-eighths wide. Now if that's not a gift for you. For today only. So smooth, so fluid, it just feels good. It has life in it. Definitely not too big, goes with any hand. This can be yours,*

you can own this." The home shopping channel women, this is what I like to hear; like Mr. B.—I understand, of course I do—how lulling go by the words.

I maintain a square stack of books next to Mr. Brooks, an island of order within reach of his chair. He had been a man of many piles, his dusty study littered with orders for tailor-made suits, speeches and postcards and old airline tickets. At some moment he'd nailed a tidy arrangement of things to the wall behind his desk: a key to the city of Venice, a document with a gold seal, one leather-framed photograph of Mr. B. with Jackie O., many autographed photographs and letters to Henry Brooks, Cultural Attaché. What is that, Cultural Attaché?

Down the hall Mr. Brooks snoozes in his chair. Can an important person, a person with a title, be forgotten?

Snooping, my explorations, have tuned me to the slightest noise. Yesterday, the sound of a dog snuffling yanked me out of a desk drawer, even though I know, I know. There is no dog here. No one comes to the apartment, no one visits or phones. Just the home-help dispensing Mr. B.'s prescriptions and me reading sorrowful words like *stab, stab* and today, *This is the saddest story I have ever heard.*

The Good Soldier, Ford Madox Ford, thirty minutes. I record what I do and the length of my volunteer time in my Compassionate Companion workbook and return to snooping the dusty study while Mr. B. dozes mercifully medicated, open-mouthed in his chair down the hall. A younger Mr. Brooks holding a martini glass is standing next to a round table. The caption of this newspaper photo reads: "Hollywood Is in Town. Another night at The Stork Club hosted by Hedy Lamarr, center; her husband, Gene Markey, to her right; Henry Brooks, US Cultural Attaché, standing; unidentified woman, left."

The woman has balanced fish knife and salad fork to stand upright on the table, the metallic A-shape nicely positioned off-center within a white damask space cleared of smoking and dining litter.

That is her kind of composition: balanced, angular, spare, lifted from Japanese design centuries old and the modern tenets of 1930s German Hochschule design.

"Oh, your utensils Miriam dear, Mim darling, you are so clever."

Away from the martinis and celebrities and photo-ready partying, the unidentified woman, left, is Miriam Eastman. Most of the workday she sits bending over a set model for the film *Two for the Road*. A miniature Claudette Colbert is standing in a miniature bedroom, the scale-model room strung with black filaments to indicate sight lines, camera angles, the invisible geometry of the film set.

Vocation is destiny, the construction of film-set models perfectly fit for the finicky, hawk-eyed Miriam Eastman. It's not her fault if too often an object ruins a scene. Twenty minutes into the film *Camille* and a vase on a mantel jarringly blooms from Greta Garbo's profile … an effect better suited to the paintings of Max Ernst or Salvador Dalí than to a scene in *Camille*.

She tells herself, "Repeat after me, a job, it's just a job," and moves on to the next project, redrawing a character's library, a second, a third time, her nails bitten to tatters, a section of her upper back taking on a vulture shape.

"A job, it's a job," she repeats, facing the smirk of Morris Schama.

She sits there, jittery Miriam Eastman, trying to pose for her portrait by master set-painter Mo Schama. The mess of his studio is ringed with panels of painted fruit. Two rows of giant strawberries recede to a vanishing point where bananas sprout to fill a painted sky. From under the fruited canopy a formation of women will dance toward the camera. Painting Miriam Eastman is release from these lens-perfect fantasies. Hard to imagine schtuping a stick like Miriam. But, oh brother, she is spectacularly boned—switchblade for a collarbone, dome of a forehead, great jut of jaw, have to improvise on the lips while she carps about some vase blooming out of Greta Garbo's head.

Schama doesn't ask where'd you get that name is Eastman some vanished goy husband or what? Miriam wants to forget the past, she's entitled. If you made it through the bombing of Warsaw and the smashup of every known pattern, then yeah, do not disturb, you're entitled to that. If you happen to be a poor relative of Hedy Lamarr's, you get invited to hobnob at the Stork Club and some putz calls you Mim darling …

At home, candles and two torch-shaped lamps barely illuminate Miriam's bungalow, California sun consigned to its place outside. Indoors the ambience is gothic: one thin female figure in a shadowed empty square. Then there were two figures, a woman and a man.

Schama wants facts. "So what's the story with that servant, houseboy of yours? Japanese, is he?"

"He's got a name—Toyo. He's not a houseboy."

"Anyway, I know your secret, Miriam dear. You're moonlighting. In houses!"

Schama's right. To make extra money Miriam is working in houses; she's carrying out the restoration of order.

The plotting of traffic patterns, the well-organized conversation pit and placement of a few chosen things, some folding screens and tightly upholstered low couches, this is Eastman interior design. The precise scatter, the elegant rigor of Japanese-German design, who can resist? Claudette Colbert and Paulette Goddard, once they'd been made to see the frippery clogging their houses, they became converts, proud and obedient, all hail their leader. Their darling Mim was good, so awfully good, they could swallow the laws of Eastman: if there has to be a bibelot, then let it be made of glass, let it be see-through and fire-made. No, there won't be any throw pillows or poufs, anywhere. The converts put up the money and Miriam went to work; first step, empty their rooms of opulence. Out with the porcelain shepherdess and her retinue of porcelain cavaliers.

At home Toyo and Miriam glide over bare wood floors in felt slippers, their shoes abandoned at the threshold. They sleep on the

floor, the sleeping mats and bedclothes disappearing into a cabinet with deep drawers sealed behind doors. No electrical cords randomly snake the floor. Secreted away, all signs of eating, sleeping, living are secreted away. Only the stucco overhead discloses the afterlife of their cigarettes and candles, gray ghosts living on the ceiling.

Toyo will never be a master carpenter at Paramount banging together walls. His are fastidious skills, family-taught skills going back and back. His small case of eight simple tools can produce furniture marvels. Barefoot he sawed and planed and pieced together a no-nails cabinet for the sleeping mats and bedclothes that by tradition should be stowed in a discreet closet; a discreet closet in a room sized by six or eight floor mats; a room for eating and sleeping and doing everything, down to dying. Miriam stroked the cabinet wood Toyo had burnished, lingering there next to the marvel of his skill going back and back. Sweet tongue and groove, she could have licked it.

Toyo's unhurried, methodical manner invaded Miriam's tight-wire system, drop by drop, some kind of potion dripping into her vein. One memorable day she put away her cocaine: Tuesday, March 20, 1943. She lay with Toyo on the sleeping mat, watching the ceiling, closing her eyes and becoming mutable, receiving his probes, his moving her this way and another for an extended spell of minute adjustments, eventually fingering herself to a shudder. A while longer and Toyo rolled two perfect cylinders of tobacco, his and now her fingers, too, scented of tobacco and her juices. No, she answered Toyo. No, she does not want to take a bath, lose to water the potency on her hands. Smoke is collecting overhead.

It's the first Tuesday of the new year, 1944, the phone is ringing. It's screen star and Eastman convert Eugene Horton. A second memorable day for Miriam.

Eugene Horton, a once-compliant Eastman convert, has materialized, crazily reborn and roaring down the line, "What are you trying to do to me? What are you? A Nazi? Jap lover?"

This is the message: Miriam Eastman has not distinguished the dining rooms and dens of Beverly Hills and Brentwood with the venerable artistry of Japan and the chaste grammar of 1930s German design. She's installed the enemy all over people's houses; a traitor is what she is.

Other converts agree: Miriam Eastman? Not a home-and-hearth girl.

1944, in the peak heat of war, the era of Miriam Eastman's high-concept decorating, the reign of Mim darling was over, simple and very swift.

She worked on in the film industry, during the war and after the war, for how many more years it's hard to know. Her name rarely appears in the film credits of her era. "Miriam Eastman" no doubt is spelled out on some old check stubs in a moldering Paramount payroll record. Her Schama portrait, her jewelry and Toyo-made furniture, all her possessions are scattered treasure, one more contribution to the migration of objects.

Deaths and door-slamming breakups send many possessions migrating to the thrift store, the church-basement jumble. There, the pungent half-life filling the lungs of every shopper is a chemical wedding of previous owners, a mingle of scent signatures adhering—how it adheres!—to cast-off things, especially to cloth-made things, precisely the things that bring Suzanne Luckas to the St. Vincent de Paul church-basement jumble in Albany, New York, her hundred-and-thirty-mile drive from Houston Street in a rented Toyota aimed for the 9:00 AM door-opening ceremony performed every third Saturday of every month—every time the church custodian is fumbling through his ring of keys, Suzanne Luckas is waiting at the speed of tires turning three hours now and counting.

She's come to purchase cast-off garments piled by church elders according to various categories of color, fiber, function, sold for fifty cents a pound, destined now to reenter the retail economy bearing the Suzanne Luckas label once she returns to her Houston Street workroom, her one-person seamstress business of methodical

dissection and reassembly, of making new garments from old, the only complication arising from that pungent phantom-infused compound adhering to her raw materials and needing to be exorcised, exposed to sunlight on the roof one flight up from her workroom from which the cloth corpses descend to the dissecting table, all previous lives lost to the sky. The lone insomniac and lovers and 3:00 AM dreamers inhabiting cast-off bed linens that will be assembled into summer dresses, through ten seasons of Suzanne Luckas dresses any trace of spit dribble and spurt of sperm and stale fart is photon-bombarded during a spell on the roof, the old gases and solids in particles scattering skyward and leaving sun-cleaned cloth ready for stitching through rounds of days without going out, rolling in and out of bed without changing clothes, all the upright hours are notes on the same CD playing over and over, the hours and the notes are stitches in time, one two three, two two three, the seasons loop round summer, winter, ten years of producing dresses only dresses is giving way now on the third Saturday in January to a new production plan: the future will be made of coats. The prototype will be ready by next Tuesday, January 20, a day anticipated for swearing in the fortieth president of the United States, his core principle repeated with such frequency in the run up to next Tuesday that citizens can recite it by heart:

– Supply is the engine of prosperity.

– Demand is secondary.

– Supply creates its own demand.

– And the flow of wealth comes trickling down.

Thus, the sewer, the one-woman entrepreneur, the name behind the label concludes: I, Suzanne Luckas, from next Tuesday for at least four years to come, I have been designated an agent of prosperity and you, my customer, already you are waiting and existing somewhere on earth, preferably of an age between twenty and forty years old, male or female. You need a good winter coat. Dear Customer, your Suzanne Luckas coat will be one of a kind, made by hand by me working on cloth corpses I'm acquiring

today in preparation for the item you soon will be purchasing, my latest, the Madame Blavatsky, will embody its inspiration, Helena Petrovna Blavatsky, she of generous physical proportions was known by countless pet names—Lyolya, Lyolinka, Linka—in the fanciful Russian system of diminutives; was variously fabricated by writers many times over in print as a fresh breeze in the heavy atmosphere of American Puritanism, in criminal liaison with the pope, the first to join science and theology, capable of materializing a teacup; was a restless traveler through thirty-six cities from Ukraine to South India, is the reason I'll be delivering the Madame Blavatsky with an extended hangtag of information, names and fabrications and locations, undisclosed in your coat's plain exterior, unlike your coat's lining I'll elaborately embroider to underscore that one phase of magical skill is the voluntary withdrawal of the inner person from the outer person. The idea is central to the teachings of Helena Petrovna Blavatsky, cofounder of Theosophy in 1850 and responsible for today's purchase of wool cast-offs, huge quantities soon to be the very thing you demand, the Madame Blavatsky will be a labor of love, a bit expensive, probably it belongs on the stage since if people write scripts with certain actors in mind, then I've in mind Debbie Harry and Miles Davis for the item you need, still-waiting customer, your new coat for this season, labor of love and expensive, its volume will come from the bodies of three black coats, of course your coat will be voluminous, Blavatsky was the size of Gertrude Stein, Queen Victoria. Thus is my rented Toyota stuffed with pounds and pounds of wool cast-offs filling the trunk, and the interior has just enough space left for the driver aiming the car toward the workroom, toward you, clamorous customer, waiting somewhere on earth and calling out for your Suzanne Luckas coat and yes, yes she's coming, the one-woman entrepreneur, the agent of prosperity, she's on a tricky stretch of the interstate south of Albany, banking into the fourth steep curve, just passing the lightning-struck giant sycamore, the third landmark about a mile from exit 19,

this is where she goes to the bathroom. The service-area food court is fragrant with air fresheners and raspberry-flavored coffee, hamburgers sizzle on a grill. Suzanne eats and reenters the traffic flow, an alarm going off in her intestines yanks her onto the shoulder to crouch in the roadside weeds with reeking body fluids flying out of her. Behind her the roar and fume of traffic, ahead a green pasture wavers into the distance heady with damp dirt, animal excrement, a small herd of Angus soon to be slaughtered. One of the creatures losing footing in the melee heading into the chute, the fallen steer, terrified and screaming, is dragged onto a conveyor belt and crushed in the slaughterhouse mechanism. Fear hormones pump into the dying animal's bloodstream, into muscle tissue ground and shaped into a disc sizzling on a grill, sliding down Suzanne's throat. Most of it she expels along the road, some of the fear-laced burger assimilates into her system, a piece of one thing becoming part of another.

A book becomes a shoe.

Pulped book paper is used for manufacturing shoes made in China, often modish but cheap shoes, a pair won't make it through a Boston winter. The slush, the salt seeps through a rotting seam, very bad for a toe already swollen and vibrating with gout. Goddamn the Gamboli family curse. All Gamboli men suffer from gout, all of them made sullen and sour. The gout legacy will not be denied, insistently making its way from the fathers to the sons, Leo and Albert. And Joseph Gamboli, he's the son who tiptoed from his dynastic assignment: grease the bishop's palm; buy the wife some jewelry; strut the streets and take no crap. The Gamboli men of Youngstown, Ohio, went around collecting a big jingle from their pop-and-cigarette bandit machines. Joey went traveling and dedicated himself to doing nothing and he'd managed all right. He had his modest fortune, the little kingdom that coke built a long time gone on some other planet that existed in the 1970s, the 1980s, who's counting?

SPEAKCHAMBER

In his monkey-fur jacket, rose velvet pants, chartreuse satin shirt, Joey now makes himself to be a lovely speck in a Boston sea of mud-khaki men. In the dull republic of restraint, he is not a citizen. The senses need frequent rehabilitation. Fuck you if you don't agree.

Somewhere in gray tattered Boston there must be a decent pair of shoes.

Somewhere in Boston it is always perfectly lovely.

Enter the apartment of Joey Gamboli, straight ahead down the green-and-pink-tile hallway, loveliness lives behind those blue-painted doors. The room in there is a memorial to seclusion and hours without function, to tea-drinking and digressions. Food is essential, elaborate food in abundance burdening brass tables low to the floor. Tonight's menu will celebrate Morocco.

An assortment of spicy olives and a *schlada*, grilled *keftas*, a sea bass and fennel tagine, another tagine of onions infused with cinnamon, seven-vegetable couscous, a coil of almond paste wrapped in phyllo pastry. Beginning, middle, end. In his white kitchen Joey assembles the narrative and props for his evening of pleasure. His dinner guest is Zoran Begovic. Tonight's meal is a love letter. *Dearest Zoran. Yes, there is darkness, there are things that make no sense. Mostar and Sarajevo, Tusla and Bihac, see? I have studied the news of your cities. You are from Yugoslavia, no the former Yugoslavia, your city is a Muslim enclave, no a safe haven, your life was in danger even if you are not what you would have been killed for. Not a Muslim, just a Yugoslav man. I understand. It's subtle, it's fluid. You are safe here. I love the way you talk. Not that you have to talk. You can always come here just to be sad. Or, to forget ... xoxoxo*

Arriving late by an hour Zoran alights uncomfortably on a little wooden stool, announcing, "Not hungry." Not aware that his chosen seat is a pre-tourist-era hundred-year-old inlaid Marrakech cedar item, Zoran's attention runs to name brands and logos, he's half leaving his wooden perch at every second for fear of Joey's apartment. Its guest-ready rooms, the daybeds and chaises and cushioned low

platforms, everywhere Zoran spies a staging area for sex. A daybed, a chaise, a cushioned low platform—Joey only sees a place for displaying his fabulous fabrics. The apartment, its four rooms are his dollies to dress. Paper them with toiles. Stripe them all French, his curtains and cushions scream in the hyperbole of crimson on black stripes, pink on chartreuse, stripes with flower buds or tiny birds pictured inside the lines. Fuck you if you don't get it.

In measured doses Joey can just about tolerate one actual family member, Anne Gamboli Coleman, cousin Anne. Today they are brunching at the Copley Plaza on St. James Avenue, the schedule made very clear: Joey has to leave their meal at 12:30 absolutely the latest. He wonders why cousin Anne is in Boston, forget it, she's already seated in the Copley's crowded dining room, jump-starting conversation at midthought: "… why are we burning rocks to charge our cell phones? One man with the right machine can destroy a mountain. To get out the coal. Mining, fossil fuel, don't you know. The rock-burning problem. It's in the paper today."

The hotel's coffee kicked in at some moment in his cousin's hash-up of the morning paper. Her hectic speech receded to a mumble, eclipsed by a single blackhead on her nose. The room disappeared and this separate small dense universe of black absorbed Joey completely.

12:30 and to his own dining room Joey escapes. To the dove-gray walls striped chartreuse, and the crystal doorknobs spraying rainbow spectrums round the room, a chip of Librium slowing his gaze. Cousin Anne no longer tearing up his brain cells, a man can disappear into the selves of things. Objects do not acquire love handles and deep facial folds. A hashish water pipe, once a dream-stoker, once a constant companion, now just sits here, silent and empty and nothing but lovely sitting here on the rug, another lovely thing, that kilim. Lean back and have your tea, think about dinner. Tonight will feature lamb. Betty is coming. Sweet Betty, she must have her meat.

"... chop the walnuts very fine and with your toasted sesame seeds you make a crust, a crunch, even your children will eat this dish, even a picky eater, even Zoran, you wear ugly shoes and too much cologne, and you overwork that raised eyebrow ..."

In his immaculate kitchen Joey chopped walnuts and talked to an imaginary Food Network camera. I walked in on his rant, no one embarrassed by that. We'd been through serious shit. Long gone are the years of grinding our teeth to a powder through cocaine-fueled nights. In a way it never happened, the shiny avalanche of forgettable talk, the two-gram ramble that could leave you pushing around a piece of dust and talking to a candle.

Good with numbers, my one skill inherited from my family of achievers, I troll ledgers and spreadsheets, my brain taxed not in the least by long columns of dollars and cents, I like it that way. Like my former self in league with Joey nightly at work, through a decade of nights, we remained minnows in the coke-dealing food chain. Therefore: we are not in jail, we are not dead. We are doing-just-fine minnows, both of our apartments all paid for up front, our expenses amounting to a modest shell-out for utilities and food and whatnot. I caretake the capital and budget the runoff money that pays the bills. With that system I am proud, I am downright thrilled with the ever-steady economy of our two allied nations, Joey and me. I go around adding then subtract, carry over and record the balance. That's minutiae to Joey, that's a fly banging against a screen. He's been in the kitchen for hours waving his hands over a chunk of meat.

And very delicious is Joey's conjuring. Once we finished his magic lamb dinner, we sipped tea for way too long, standing the whole time for some reason in the trophy room with its small Warhol-painted dollar bill, its eight-inch Eva Hesse resin object, its collection of maybe fifteen or so artworks bartered for some grams of coke consumed years ago in a couple hours. Suddenly Joey announced he was thinking of moving to Switzerland.

"Really? What's your idea of Switzerland?"

"Not an idea, I know la Suisse. Switzerland was my drug-turnaround place. I'm talking Zurich mostly. I could cart out some of my money in the, I mean *the* loveliest clothes and furs and antiques and the country was a cache of exotica, don't ask me why. I hate most of that chinoiserie now." He jerked open a closet. "See what I mean? Detestable stuff, very gargoyle-y, I don't care if it has something to do with religion. Buddhism, of course, is a beautiful thing, I'm sure I'm a Buddhist. Aren't we all?"

I unrolled some brocade leaning in the closet corner. It wasn't chinoiserie. I unwound an old towel wrapped around something heavy. I was holding a metal statue, maybe a Buddha. A thing of many details, it was emitting heat in my hand. And from far off, Joey said: "Give me that hideous statue, it belongs in the closet." A good two weeks later, walking with Joey I tried explaining how the statue in his closet had taken up residence in my head, as if some part of my brain is wax and all the details are embossed there—the row of petals inscribed on the base, the body in a left-leaning attitude, hands positioned like this, each finger is posed, one leg is bent, the garment is folded into a design … The tedium of all this registered when I heard myself explaining as we walked, heavy going in the snow.

An epic blizzard had enclosed us in Boston snow, everyone united in a single event: a thirty-year record broken by storm number two piling eleven more inches onto the twelfth snowbound day. Numbers streamed out of our radios and televisions, all information now. We even learn the truth about snowflakes. In the words of the radio: "No two are ever the same but every flake, every last one is shaped of exactly six arms, because a snowflake is a crystal and the structure is always the same, always the six arms."

Supremely uninterested in my performance of snowflake facts, Joey didn't always make the best girlfriend-confidante and so we tramped on in the heavy falling snow. Not talking, alone in a muffle of self-made sounds—wool rubbing against wool, the in- and outtake of air—it was like walking inside a bottle, and outside there was little but white.

We were resuming our monthly visit to the Isabella Stewart Gardner Museum, almost alone in its galleries, reopened after a week of snow days. Up the stairs, we began our never-deviating tour, Early Italian Room, Raphael Room, Little Salon, Short Gallery, Tapestry Room, Dutch Room, clockwise room to room, left to right.

"Ah." Presumably the sound came from me, unnoticed by Joey moving at his usual pace in the direction of the Tapestry Room, undeterred by the ah-inducing object in a small silver vitrine. A tiny Buddha, maybe two inches, sat there with an abundance of details I recognize at first sight. First sight … I have been trekking the Gardner for over ten years, have put in my time right here in the Little Salon, in front of this very vitrine. Here, today, among too many miniature objects precisely positioned by Mrs. Gardner in their miniature glass prison, here two inches of gold shaped similarly to Joey's closet statue is an unknown thing projecting recognition at first sight.

And again: behind glass on a shelf in the Short Gallery, here for the first time is a drum or a wheel on a wooden handle, clearly belonging to the same category as the statues. The look of it, the details inscribed in its metal tell me so, the thing seen never before.

I could depend on Joey to be following our undeviating route, he would be in the Dutch Room, and perhaps he was there. My attention was hijacked by a bell Mrs. Gardner had set on a table in front of her Vermeer. Another small article unnoticed all these years, the bell with some kind of design on its rim and belonging to the category fast becoming recognizable.

We maintained our usual course, turning toward the café, me carrying in my head the collection of small objects just encountered for the first time. At a table next to a window, always we end our Gardner tour here, attracted by the museum café's amazing cakes and ginger tea specialty, also amazingly sweet. Hopped up on sugar, the portable collection of just-discovered things—figure and wheel and bell … all of it to Joey's mind is, he said, "supremely uninteresting."

Still, when I find myself in the Gardner Museum Library, I agree with the world, yes one thing truly can lead to another, has indeed led from a stashed statue in Joey's closet to the library on the museum's top floor, fairly straight this path posted along the way with heat and wax and snow and bells and wheels and sugar.

This is what I come upon in the library: Isabella Gardner's journal from her travels in Asia, 1883–84, including a sojourn in India.

Mrs. Gardner scrawls on for pages in an impossible handwriting. Her fanciful ornamental marks, some of them begin turning into words under my eyes: *Friday, February 25. Off by train for Darjeeling. Sunday, February 27. Bought Tibetan prayer wheel.*

February 27. Bought Tibetan prayer wheel.

The words cause a satisfying shift deep in my head. February 27, the same date as today. Mrs. Gardner in Darjeeling a hundred and ten years ago, me back in the bottle slogging home through new snow falling on top of the blizzard-delivered thirty-one inches. How inconvenient and daunting it must have been to lug around one's hatboxes and trunks and accoutrements in February a hundred and ten years ago in the upper altitudes of Darjeeling.

One solution to the physical challenges of traveling the seven-thousand-foot Himalayan foothills is to arrive there and never leave. Alice Benning in her thirty-sixth year of never leaving Darjeeling paces her terrace, waiting for her nephew to arrive. Twice a year he comes, David Shaw, with his features recalling once-close relatives not seen in decades. They all live in Kensington, Holland Park, or is it Notting Hill, their latest too big and ugly and dirty London address. Let them believe Darjeeling hill station days are no more.

Things are right at Benning Cottage; the laundry girl has finally finished ironing the sheets and napkins, the kitchen boy is ready with lunch. Alice will have a nice sit among the geraniums. Things will be right again in an hour, around one o'clock. David will arrive; he'll be bringing up the mail and some fruit jams impossible to buy

in the District, they will have their nice lunch. She is horizontal by 9:00 PM, Aunt Alice exhausted from so much waiting and preparing for David's visit.

Tibet Restaurant has prepared for David, too; news of his arrival delivered early in the morning. By 9:00 PM it's full up with men, Tibet Restaurant, a beer-and-noodle magnet for ex-monks and former Tibetan resistance fighters. The men dress in Shaw-supplied American blue jeans and puffer jackets and, after a second beer, they're passing around the stories. Brief enough, little nuggets really, the former resistance fighters' often-told narratives have worn down to the mudslide that buried five horses; four thousand Chinese on the hill; fifty reinforcement fighters arriving too late. Grief is on the men exiled in their restaurant hangout, all welcome-back-Shaw sentiments drowned in endless rounds of beer and bellowing for home. "Po!" "Gyalwa Rinpoche!" Eighteen years since Gyalwa Rinpoche escaped Po and became known as the Dalai Lama escaped from Tibet; five going on six years since Shaw began living among Tibetan exiles in Dharamsala. Everyone counts the years. Tomorrow the men will go north and revisit 1950, year one of the Chinese takeover. Gendhun, a former resistance leader, is in charge. Gendhun's plan: meet at Chowk Bazaar, seven in the morning, or thereabouts.

North of Darjeeling and non-residents of the area are required to travel on a temporary visa. Shaw has been keen to go up there, to stealth into the restricted area under cover of the landscape and the expertise of Gendhun's guerrilla skills. The word is: be prepared to encounter a Chinese military patrol taking on escaping Tibetans, news of which is heard from time to time in Darjeeling. Shaw wouldn't mind getting into a border skirmish, knowing that fighting alongside escaping Tibetans is an unlikely event. The popular escape routes are much farther east along the four-thousand-mile border; the morning's destination, north beyond the gateway market city of Kalimpong on the once-lively trade route connecting Tibet and India, is too policed, too watched. To get there the group drives into Kalimpong

in a borrowed Jeep and strolls to the outskirts, crossing into open land. Wading through rhododendrons, Gendhun, navigating with no path, not one landmark, and without warning it is over. The trudge through thick growth has come onto a stack of stones. Gendhun adds one to the stack, they each add one stone: "We were here, we are here again," in stone. Farther north across the border the Kanchendzonga mountains advance ridge upon ridge toward the Tibetan high plateau. The men are standing at a window with the blind drawn, the forward view of mountains blotted out now by a dense white mist, and behind them the landscape remains in its own cloudless light, clear back to where they left the Jeep near the market.

No one wants a cup of tea or a conversation. The morning's expedition only just completed, the aftermath is depressing: the men can look to the border they cannot cross to go home. Shaw alone has managed to translate a myth into a life. David Henry Shaw, the former college-going kid, half American, half British, is an old-school trader on the ground, crossing closed borders, ferrying goods between distant populations who lust for each other's stuff.

He explains to Aunt Alice maybe she should have her tea out this afternoon, he needs Benning Cottage to, "you know, see to a little business."

The business started rather late, the visitors to the cottage not yet accustomed to the wristwatch. They had been walking for four months, two cousins, Lobsang and Thundup, walking from Tibet's Lithang Valley and a week ago into Darjeeling. Shaw knew the look of them, bashful and awkward and not yet adjusted, the weather still on their faces—wind and sun and unnamable conditions of the high plateau. Yeah, he knew the situation in a glance: "Lithang, isn't it? Your gompa-monastery is in Lithang District," offering the camaraderie of the clan.

The new exiles are at the cottage to sell a curved knife, a silver spoon, a small old rug and a pony blanket, a man's turquoise earring and the last item emerging from inside Lobsang's *chupa* coat—

SPEAKCHAMBER

a small Buddha, maybe six inches, maybe a Chenrezi. "Yes, Chenrezi," from the cousin who does the talking and passes Shaw the figure rescued from their abbot's private rooms. Jailed in 1960 and not a word of him, Lobsang and Thundup escaped with not a word of their abbot for fifteen years.

Religious value is increased if the statue has been the object of meditative concentration by an accomplished practitioner. The thought surfaces from time Shaw spent with Theo Hennig.

The Buddhist scholar from Germany, every day Hennig was slaving over a cache of manuscripts at the Dharamsala library and talking to Shaw over a beer every night at their hotel. Shaw copied down the impressive points of the German's scholarship in the notebook he was never without.

"Yes, a pretty good Chenrezi," Shaw finally responded to his guests.

He could have told them statuary is always the last thing to sell. His European customers want paintings, they can't get enough of Tibetan *thanka* paintings. No, he wouldn't be getting much for the Buddha, the turquoise earring would fetch more. He would wear it once the sellers left. "I'll take everything, I'll pay you outright, say two thousand rupees," knowing what it takes for the former monks to sell their abbot's consecrated statue; one more in a series of worst events—their sacred vows broken, robes laid aside, their monastery looted and shelled into rubble while they hid and watched. *Religious value is increased if the thanka or statue has been the object of meditative concentration by an accomplished practitioner.* Yeah, he knew all right. Shaw was reckoning he'd claim three hundred dollars at airport customs for everything he was purchasing from the former monks; a humble sum always yields an entry stamp in his Commonwealth passport, no questions.

Next visit he will spend more time with Alice, promise. She has prepared sandwiches for his trip, sandwiches and a thermos of tea. The same travel-ready meal she probably served his grandmother. Already she's back to watering her geraniums and asking if her napkins have been ironed.

Shaw finished organizing various refugee artifacts into a bundle. Backpack in position he left for the wearying twenty-six hours of traveling by Jeep down the mountain, train to Calcutta, flight to Hamburg, destination Zurich.

He arrives smelling of woodsmoke and months without bathing, a solid crescent of dirt under his nails. He arrives at Galerie Becher, Rudi Becher's business in silver antiques run by Rudi's niece Toinette. Toinette with her silver-polishing cloth, David with his dirty nails, they stare at each other across an eighteenth-century sauceboat on view on the counter. Dumbstruck after an eight-month separation, Toinette and Shaw take their time. Soft and horizontal, the welcoming chaise is faithfully waiting for them in the Galerie back room.

Waking in the morning to wet snow falling, Toinette hovers at the Galerie front door watching a familiar sight: Shaw heading down Graue Gasse, a stalk of a man leaning into the falling white, tall and all in black, all business. She likes him a lot; she likes him seldom in town, frequently in her thoughts. An unknowable mechanism tosses him up in Zurich, fabulously disturbing the days otherwise set to unlocking and locking the Galerie, dusting the sliver inventory and waiting for a customer, quarreling with Mother.

Eight days later at the door again, snowing again, the same colorless sky down to street level with the black stalk striding through the white, Shaw is on the move again. Gone from the Galerie, soon from the country, the tall figure in his yak-wool coat, already he is just an imagined presence available for the random imaginary conversation.

He's left behind some objects he'd like her to sell to her high-toned customers. Any silverwork European-made from the 1600s through the twentieth century, any piece of work and Toinette can pretty much articulate its every feature. She's picked that up osmosis-like growing up in the Galerie, giving hope that her mind will sponge some understanding of these strange and difficult items Shaw brings with him from some town that begins with a D … Darjeeling, or maybe it's Dharamsala.

Toinette passes the morning fussing over what to display in the show window to replace the eighteenth-century French sauceboat, yesterday's big-ticket sell. On the counter for consideration she has a candidate for the spotlight in the show-window theater—one of Shaw's statues. She had been quarreling with Mother. It's a strange item, an eccentric thing. She will have to emphasize its gold content, have to research the iconography. Quarreling about everything, Mother always jawing on about something.

The day of waiting and dusting yields one customer at closing time, rather taken with finding her talking to a fork. "This little stray survived being melted down at the Royal Mint during a fiscal catastrophe—one of the Louis, XIV or XV. And it went with a spoon that's gone missing. Anyway, this little stray is what's called a masterwork, the example-object made for passing the guild exam. It's virtuosic, fantastically ingenious, this great quantity of design in this tiny space of the handle. Hidden erotic symbols, clearly a specialty of the craftsman who worked on it. Probably an immigrant, maybe Flemish or in the Huguenot diaspora, anyway, a talented immigrant. Some people don't care for or approve of a high shine. They prefer a minimal rubbing off of the tarnish. Some of the oxidation should gather in my opinion, here especially where the chasing … Oh, this must be boring."

Customer: "Not at all, I'm loving this."

Toinette's mother, Madame Doctor Becher, bangs through the Galerie door, her mouth opened to the dispute she's been gnawing on. She Geigers the customer up down, taking his measure on her meter. Mother wants to know: "Have you seen your uncle today, Toinette?"

"He came downstairs, forgot his teeth in his bathroom, went back up to get them. Then we had lunch, it's been a good week, we sold an important sauceboat …"

"I can't bear it; the two of you holed up in here measuring success in sauceboats."

The late-day customer scuttles away, Mother Becher goes to the window with a view of her esteemed city, Toinette idly turns the show-window candidate, Shaw's strange sculpture, around, around. The figure is quite like one she saw in a book. Perhaps not. At this early stage of learning, the motifs and symbols are still remote and unreadable. One book has a reference to the pattern inscribed on the base of the rotating statue; the *dorje* it is called, the lightning bolt. A paragraph later it's called a *vajra*, and then it's identified as Dorje Ling, the original name for Darjeeling, one of Shaw's haunts.

Any silverwork European-made from the 1600s through the twentieth century, any piece of work and she can pretty much articulate its every feature. She's picked that up osmosis-like, giving hope that her mind will begin to sponge some understanding of Shaw's niche items embedded in systems less apparent than any she knows. It isn't easy to see anything lightning bolt–like in the statue rotating in her hands. She begins to see the figure is moving faintly, inhale-exhale, and repeat, it is inhaling-exhaling. She sees the face is changing, becoming no longer youthful, no longer midlife, old, very old, it is no longer aging—the face that is now a skull without a distinguishing feature.

One of the books said: "If the meaning or content of symbols is forgotten or not known, one sees an art form or an ornament."

The figure has stopped breathing.

One of the books said: "In its life the effects of having the visualized presence of the Buddha projected onto the image by a practitioner are cumulative … the history of mental imaging is a factor in its vivification."

The figure has stopped breathing. It is no longer aging. The Buddha has resumed being a metal statue with something called a *dorje* motif inscribed around the base.

NOTES

P.123 *"If the meaning or content..."* Ernest Fenollosa, commenting on Asian artworks in the Museum of Fine Arts, Boston (ca. 1890): "If the meaning or content of symbols is forgotten or not known, one sees an art form or an ornament." "It is not quite enough to use the terms of iconography freely and to be able to label our museum correctly. Identification tells us nothing of meaning."

Fenollosa was a social acquaintance and contemporary of Isabella Stewart Gardner; he belonged to a circle of Boston intellectuals (the "Boston Orientalists") who studied and became knowledgeable about the arts of Japan, China, and Tibet, and who contributed to the acquisition and development of a collection at the Museum of Fine Arts, Boston, where Fenollosa was curator of the Department of Oriental Art, 1890–96.

"In its life the effects..." This passage reads, in its entirety: "In many ways the very history of the image is a factor in its vivification; in what rituals the image has been employed, what monasteries have kept it, and especially what lamas have been in contact with it. The effects of having the visualized presence of the Buddha projected onto the image are cumulative." Janet Gyatso, "Image as Presence," in Valrae Reynolds, Janet Gyatso, Amy Heller, and Dan Martin, *From the Sacred Realm: Treasures of Tibetan Art from the Newark Museum* (Munich: Prestel Verlag, 1999), 172.

SPEAKCHAMBER

TWILIGHT

2020
SPOKEN TEXT, VIDEO, AUDIO
10-INCH SENSOR-ACTIVATED DIGITAL FRAME
3:02 MIN.

Seems you're alone walking, walking seven blocks south four to
the east tracing the way home. And ignoring the red "Don't Walk"
signal the intersection gone quiet for some reason, crossing against
the light you're in the path of many years-old currents coursing
your wires. One sender, the singular one, they're stirring the quiet
the dark the quickening pulse you sense any moment now the
unforgotten one, unseen in seven years, at any moment they'll come
around the next corner. You hear in effect until further notice expect
a brutal heat dome to grip the Northeast and possibly the end of
tribal mindsets that wall us into defense units by assembling all
humans on a single family tree is yesterday's podcast in the air now
expected to reach a dangerous 115 degrees. So much bandwidth for
dwelling on what everyone knows almost nothing about the weather,
money, money the weather, everyone every day enmeshed in the
same systems in effect until further notice. I'd start planning for the
future said your well-meaning friend, meaning arm yourself with
insurance, meaning there's a business marketing the future—illness,
injury, calamitous weather around the next corner it's coming at any
moment. And you once supposed in the future to seek sustenance
would be to taste of all human undertakings: with every breath
people will inhale fuels buildings machines; people will drink roads
clothing electricity; we will eat endless things that were made by
our hands machines instruments. In the future it will be impossible
to keep such things separated in the intersection, in the path of
many year-old currents the unforgotten one unseen in seven years,
at any moment they'll be walking in the air you're walking through
seems to reach Venus, crescent moon. Seems you're alone walking
the topography of twilight, though on a chart mapping the United
States of money you're among a high number of low earners. High
number of low. Impossible to keep separated money the weather,
clothes, food, windows of glowing light, trees of darkening gray, the
lost one the ghost of a chance shadowing your every step south, four
blocks to the east.

THIS FEELS LIKE

2020
SPOKEN TEXT, VIDEO, AUDIO
10-INCH SENSOR-ACTIVATED DIGITAL FRAME
2:03 MIN.

This feels like a minute is an hour spent on what I heard yesterday that we spend two-thirds of our wakeful hours daydreaming and one-third of the day we spend sleeping. Today those same facts are sent into the space of much repetition. One-third of the day in sleep. Two-thirds daydreaming. I also heard today possibly an end a man is explaining algorithms will potentially eradicate long-standing beliefs by assembling all human beings on a family tree under construction with data-collecting algorithms predicting the conclusion possibly the end of tribal mindsets that wall us into defense units is yesterday's podcast in the air. And I heard a critic of the Justice Department say if they can get you asking the wrong questions they don't have to worry about answers. Furthermore eye roll is to fact as your word is to mine as in the story comes to us from independent sources, you have to accept our premise is promise that's the price of admission. There's some debate on where you come into it, try setting the record straight, jump-starting the process, changing direction here. If it meets our premise and promise happy to deal, happy to be prudent on point nine, to be aggressive as called for in mandate number 879 page 451. To repeat as there seems to be a failure on your part to understand. Let's be clear here. We have the video as in no one will ever see the evidence is to lying as lying is to water. Don't make us get the board.

THIS FEELS LIKE

FREQUENCY HOPPING 2

2018
SPOKEN TEXT AND AUDIO
3:05 MIN.
TRANSCRIPTION AS DIGITAL PRINT
WITH INK-AND-PENCIL DRAWING
IN LIGHTBOX, 17 X 22 IN.

One thousand one. One thousand two. Day five of sleepless nights.
You know the cure for insomnia: leave your bed, in two thousand steps
you will be a mile from home.

Under a broken streetlight blinking on and off, you pick up:
9 9 9 00 w 7 9 a
Low-level intelligence, maybe sixty alphanumerics a minute, encrypted
on a narrow channel of shortwaves you're picking up under the street-
light, the cold war never ends in the sender-receiver matrix. In the air
you're walking through, Finland doesn't exist. The Queen of England is
a cannibal. The Apollo 11 moon landing was faked. Barack Obama was
not born in the US. Most of the world's leaders are related to tall, blood-
drinking, shape-shifting reptilian humanoids from the Alpha Draconis
star system. RFID (radio frequency identification) chips are secretly in
widespread use, embedded in humans.

Wavelengths, vagrant messages in the air you're walking through …
people have long believed sound waves, once made, are ever present.
Some people claim to be receivers of voices, of low frequencies, while
you—tonight you just go around with an earworm is all you hear.
Sorrowful is playing on the bandwidth in your head, one thousand one,
two, up to four thousand fifty-seven steps, you've walked one mile west,
nearly one mile north are four candles and some flowers on a patch of
sidewalk, one more vigil on the calendar you're nightwalking where …
Alicia Walker, your upstairs neighbor, is four candles and some flowers on
a patch of sidewalk where you're heading. Alicia, one of you-lost-count-of
people gunned down this year, they flood your hyper-wakefulness, all
the gunned-down souls always seem to begin with all the gunned-down
souls in Mississippi Chicago Kent State Akron Dallas Atlanta, always in
the air you're walking through if you're not part of the solution, you're
part of the problem, if you have an answer for everything, you're not
asking the right questions, slow it down now. In eight hundred seven six,
in five hundred four three, in two hundred steps you'll be home.

One thousand one one thousand two day five

eave your bed, in two thousand steps you will be a mile
ou pick up nine nine nine W zero zero seven nine. Low
lphanumerics a minute encrypted on a narrow channe
old war never ends in the sender-receiver matrix. Freq
inlanddoesntexistThequeenofEnglandisacanibalApoll

raconistarsystemRFIradiofrequencyidentificatio
ave lengths, vagrant messages in the air you're walkin
re ever present. Tonight you just go around with an ear
our heard, one thousand one, two up o four thousand n
orth is four candles and some flowers on a patch of si
here Alicia Walker your upstairs neighbor

f sidewalk where you're headed, Alicia one of you lost
akefulness, all the gunned down souls seem al
hicagoDallasAtlantaalwaysintheairyou'rewalkingthro
nanswerforeverythingyou'renotaskingtherightquestions
undred four three in two

epless nights. You know the cure for insomnia

me. Under a broken streetlight blinking on and off

level intelligence, maybe sixty

ort waves you're picking up under the street light the

s, vagrant messages in the air you're walking through

onlandingwasfakedBarrackObamawasnotborninthe

aresecretlyinwidespreaduseembeddedinhumans.

gh people have long believed sound waves once made

s all you hear. Sorrowful is playing on the bandwidth in

en steps you've walked one mile west, nearly one mile

x, one more vigil on the calendar you're nightwalking

some candles and flowers on a patch

of people gunned down this year, the flood your hyper

to begin with allthegunneddownsoulsinMississippi

ou'renotpartofthesolutionyou'retheproblemifyouhave

low it down now. In eight hundred seven six in five

dred steps you'll be home.

IN A CABIN

2016
SPOKEN TEXT AND SOUND MATERIAL
INSTALLED ON VINTAGE RADIO
PERFORMED LIVE, 16:49 MIN.

Waiting. An inch measures an hour on the candle clock. One inch of beeswax, one hour of time. And another thing. Our four-day weekend in a cabin in the woods without electricity, tick tick, the firewood's running out; dripped away, all but one of our candles have dripped away.

An hour is, whole days are long with wanting. What a beast is longing. There it is hanging from the ceiling.

Four o'clock, five …

For dinner, wanting something dusky, tasting of the woods. That's why I went out in the rain, in the far south corner of Seneca Woods to be precise, precision becoming pretty much all that mattered this night made long by Detective Carlyle's interrogations. Wanting some dusky-tasting morels with dinner made no sense to the detective; Carlyle could not get beyond why I was out in the location that's now her crime scene. If you are chasing down a suspect, the lure of a mushroom must sound sketchy.

Likewise sketchy: the lure of a fleshy spore-bearing fungus for dinner, if you take seriously the poison reputation of wild mushrooms. The thought of ingesting one and of getting rained on and dirty from foraging in the woods, that's why you stayed behind to watch over the stew. That stew, you said, it's a bit of a production. First, vigilantly feed hardwood into the iron stove, a chamber for roasting seven pounds of bones: step one of a seven-hour process. The art of numerology is immediately apparent, that's how old is this recipe, laced with numerological valences—sevens and sixes, mostly.

Six onions, six carrots, seven celery stalks roughly chopped go into a pot of boiling water: step two and the future is already in the air. Tomorrow will taste of a chemical wedding, the bonding that makes ingredients taste better for spending the night together in an iron pot.

IN A CABIN

Iron and fire.

Nothing that plugs into a wall socket.

Our four-day weekend at the cabin is meant to be off the grid.

All quiet on the porch is where you stand waiting and in the south corner of Seneca Woods, Detective Carlyle and her colleagues and I, we inhale smells of cat urine, rotten eggs, wet diapers, and fertilizers. The crime scene, a pile of still-burning wood and chemicals: apparently the remains of a meth lab, must have been an explosion, at least two people dead, a trail of footprints might indicate a survivor, Carlyle was putting it all together. Why, she just wants to know why am I out in the rain in the location that's her crime scene. And then I am in the back of her cruiser.

The plan is to reset our inner diurnal clocks: four days governed by the fall equinox. Getting in sync with the season, alone in the cabin, you collaborate with iron and fire, the air increasingly stew-fragrant and spook-filled. You said, my time in the woods is your head in that place, your head troubled with the likelihood of abduction, my encounter with wild animals a sinkhole a stranger, always a man, skulking dark woods dripping with rain, and you pacing off time on the porch.

Two hours, the detective kept me in her cruiser for two hours, an eternity and a streak of seconds racing so fast in—what is it—eight square feet of space in the back of the cruiser. I'm saying the same things over and over, talking to Carlyle, communicating with her is excruciating: her belligerence, her smug expressions. All right, I am not getting an excessive-force backseat beating, I am trying to believe I am still in a free country, one of its enforcers, precision and extreme eye contact scaring me obedient in the back of her cruiser, the whole time I am staring at the one intact vestige of the exploded meth lab, painted in red: Beware of Dog. Aha, you say,

that explains the Rottweiler trotting out of the woods. I am on the porch, keeping watch, sweating from your possible demise. Wild animals, a sinkhole, that man always skulking the woods? That man is one of four, the three others loafing around a cluster of stolen cars in a nearby clearing. They live there, they live off the take of small burglaries, always plotting the big one.

You know, I say, I like it better when you stick to your beloved elements. Hydrogen, oxygen, nitrogen, carbon—the four great agents of living things bond in innumerable combinations. That's what you told me. You said stars are one of the combinatory products, also the great furnace in the sky, the sun in equinox. You said your stew is one of the combinatory products. Seven hours of recipe, very old. You love reenacting history in a pot on the stove. When I think about it, how old is old? Seventeenth- or eighteenth-century old? This cabin your family built, our four days off the grid, aren't we on a troubled disputed piece of ancient earth.

Well, you say, if I were you I would have been on a different part of the land, not radar-equipped to find anything, absolutely anything to do with drugs and you'll find it. Your first love bone china is heroin is the street name, that's what you told me. You said, your lost decade on the street … anyway, let's get through one night without remembering all that. It's a remarkable day. A precise division, sun and moon in equal parts, a twice-a-year event in the sky. In history the equinox is often occasioned by synchronicities, a system of coordinates, like today, I could say: on a quadrant of woodland mushroom-rich on its topmost layer is where you're foraging is exactly where there's a meth lab is on top of my family's acreage is on top of the Iroquois Nation, as you say, a troubled disputed piece of ancient land.

We decide it's time to set the table for dinner.

A last candle drips away.

A forgotten Coleman lantern in the closet, one thousand liquid-fuel lumens, damn! Bring it to the table, we'll dine in the lantern's glare, jumping shadows on the walls. And noise, the room is painful with hissing.

I turn down the hissing lantern, gently flick my dinner plate, the ring of bone china, key of C, I sing:

> *Bone china*
> *My friends*
> *Bone china*
> *Let the summer come again*
> *I'm talkin' to you*
> *Oh, oh, she be dancing by the moonlit sky*
> *Oh, oh, she be movin' like a butterfly* *

There is no butterfly when we set the table for dinner. No butterfly on our plates, a couple of bluebirds, yes. What they're doing there I've no inkling why people, why we want to eat off birds and flowers and vines pictured all over our plates. The actual bones of china— that's sensical, that's about adding strength to the plate. Twenty-five to forty percent of bone ash will do that. Also will add some transparency and a certain clear ring as I demonstrated on that fine example of bone china.

I can hear you saying for the second time: If I were you I would have been in a different part of the woods, not radar-equipped to find anything, absolutely anything to do with your bone china first love … anyway, we're getting through today without going back in time. It's a remarkable day. I don't mind devoting seven hours of it to cooking a meal low on the food chain. Supposedly it's an upward

supportive energy flow for the planet, eating low on the food chain. Unless the food pyramid collapses. True story. A gang of outlaws loitering around a cluster of stolen cars in a clearing in these woods, they live there. They live on the take of small burglaries, always plotting the big one, unphased by their frequent bungles—like the not-rich guy it turns out once they break into his big house, so they leave a piece of him in each of the rooms where they were expecting to find a rich man's loot.

You can count on me to say: What a load are expectations. Wanting, wanting can make a night, whole seasons, every day is long with wanting. Such a beast that longing. There it is hanging over the dinner table. Your grandfather probably built this table when he built the cabin.

OK, great-grandfather, it's an old old place.

By the time your great-grandfather builds his cabin maybe he's ignorant of the onus of land-grabbing that sticks to a white man. Maybe he is a widower so longing for his wife and starving for his lost days of ordinary beauty, his mourning turns a widower into a malcontent. And deep in these woods, he lives off canned sardines and bourbon; a withered guy teaching himself to whittle tree branches into spoons, into connected links of a chain.

Seven o'clock, eight, finally we sit down to dinner, your seven-hour stew gone in fifteen minutes. We stare at our plates scraped clean, two inches on the candle before we go dark.

* Lyrics to Mother Love Bone, "Bone China," on *Apple* (Polydor, 1990)

IN A CABIN

WAITING. AN INCH IS AN HOUR ON THE CANDLE CLOCK. AND ANOTHER THING.

THE FIREWOOD'S RUN OUT. DRIPPED AWAY, ALL BUT OUR LAST CANDLE DRIPPED

IT IS HANGING FROM THE CEILING. FOUR O'CLOCK, FIVE.....FOR DINNER; WANTIN

SOUTHWEST CORNER OF SENECA WOODS TO BE PRECISE, PRECISION BECOMIN

INTERROGATIONS. WANTING SOME DUSKY TASTING MORELS FOR DINNER MAD

LOCATION THAT'S NOW HER CRIME SCENE. IF YOU ARE CHASI

.7

Y WEEKEND IN A CABIN IN THE WOODS WITHOUT ELECTRICITY, TICK TICK, THE

UR IS WHOLE DAYS ARE LONG WITH WANTING. WHAT A BEAST IS LONGING. THERE

G DUSKY, TASTING OF THE WOODS. THAT'S WHY I WENT OUT IN THE RAIN, IN THE

UCH ALL THAT MATTERED THIS NIGHT MADE LONG BY DETECTIVE CARLYLE'S

TO THE DETECTIVE, CARLYLE COULD NOT GET BEYOND WHY I WAS OUT IN THE

SUSPECT, THE LURE OF A MUSHROOM MUST SOUND SKETCHY.

2017–18
UNPUBLISHED TEXT
OF MULTIPART WORK, INCLUDING
SPOKEN-TEXT AUDIO WORK
INSTALLED ON VINTAGE RADIO
AND DIGITAL PROJECT FOR *TRIPLE CANOPY*
PUBLISHED MARCH 2018

My sleep, always so lively with visits from former boyfriends and formerly living people, my sleep became hour on hour restless and fretful, September 21st and 22nd and 23rd.

September 24: Whoever you are, DIY carpenter from the past, I call you genius for installing a skylight in the bedroom. That aperture right over my bed, it's an antidote to insomnia's dread and anxiety, delivering Saturn and a bit of moon and a star assembly I never took in until now.

September 25: How the chance longitude and latitude of my building determines my nightly view. September 26: How my southwest patch of sky is an enormity of light-years and millions of miles and celestial mechanics trimmed to the skylight's six square feet of glass.

September 27: How the sky is full of ghosts, tonight's light emanating from astral bodies long vanished. Those vagrant musings showing up in the dark is how immensity and insomnia fuel the end of September becoming October first second third, every nightsky so nearly identical, oh. The antidote to wakeful fretful nights, it's waning, it's losing power.

October 4: Impatient to get somewhere with sameness and predictability, tonight is all about moving a pen across sheets of translucent paper, making my way around the sky, connecting stars that have become my familiars. People have always done this, drawn random distributions of stars into recognizable figures and shapes—swans and bears and utensils and mythical men. Asterisms, they're called. How like near neighbors appear the members of an asterism, individual stars separated by light-years. Swan and bear and Hercules … really? Of the hemisphere's storied inhabitants, the only legible figures I detect are Big and Little Dipper, poised to ladle what, I don't know.

October like one long night, three satisfying weeks piloting between the brightest members of my outer space with my pen aimed skyward. My pen is a product of space travel, resisting gravity, the ink flows up- ward onto paper held over my head. A needle inside me plus the axis of the earth plus the pen point make a hybrid instrument, part protractor, part compass—a conspiracy of inner and outer magnetics plotting triangles and circles and polygons. Not one animal or mythical person makes an appearance. Order, my sky hosts a notion of order projected onto a flat black plane, an illusion that plane—and, October 22, on my skylight fallen leaves are congregating. Up they go, lifted by wind. Spinning leaves extend to the stars, I see that now, I see spirals now I've left the confines of bed for the grand access of my roof, mercifully flat under sleep-deprived legs turning north to east south west. We spin, me and the sky, my partner in this dance.

October 26: A 3:00 AM moaning wind blows the skylight clear of leaves and I wonder if twenty-two nights of insomnia-induced concentration, if my singular focus is a dense locatable spot in the extended territory of matter. I wonder because around 4:30 while drawing tonight's asterism, my pen moving across paper writes of its own accord: Oh Be A Fine Girl Kiss Me.

A tight beginning loop that is small is watchfulness speaking. And a lightning-fast mind is indicated in needle-pointed strokes. Under analysis, subjected to the principles of graphology, the handwriting reveals its author has a keen memory and tremendous patience, a driven and self-reliant person. Indeed, that is how she is remembered, Annie Jump Cannon, astronomer at Harvard's observatory, sitting at her viewing station from 1896 to 1939 classifying three hundred stars an hour, the numbers accumulating to more stellar bodies than any other person had classified. For this you are called "Census Taker of the Sky," Annie Jump Cannon, you and a room full of women all day

at your viewing stations you are scrutinizing glass photographic plates, images of night skies at the reach of 1920s telescopes and cameras. At some moment, you realize the entire star multitude is composed of seven factors, seven spectral classes of stars summoned in the mnemonic Oh Be A Fine Girl Kiss Me.

October 29: I read: Cannon identified three hundred variable stars, five novas, and one spectroscopic binary, creating a bibliography that included about two hundred thousand references. I read: The International Astronomical Union is still using the classification system of Annie Jump Cannon and that she could classify three stars a minute just by looking at their spectral patterns and, if using a magnifying glass, could classify stars down to the ninth magnitude, around sixteen times fainter than the human eye can see. I know: distinguishing seven distinct intensities of star brightness, OBAFGKM, is beyond my observational skills. And there's the limit of my view from bed. The O, the brightest star category—Polaris, for example—is never in my patch of sky, my overhead inspection additionally hampered now with leaves returning, insomnia persisting. When I think a month ago sleepless in the company of immensity, how I loved my sky companions waiting for me every night. Among distant figures consorting over my spot of Earth and past time materializing in my present and dead stars giving off light, I wondered over distance in light-years, millions of miles. To those month-old musings in the dark I wonder, too, how until a few nights ago I never knew of Annie Jump Cannon. And for two weeks now I am waiting, waiting for you, Annie, you know what it means to be taken by the sky, why won't you again take hold of my pen, scrawl with me one more time. Without your enlivening input, nights are plane geometry, nights are a creature of pattern recognition abandoned to find my bearings, make my way accompanied only by the most forlorn refrain, carry on carry on that's how it goes, the chorus of the left lonely.

November is nights of tracing the sky is the balm of habit tranquilizing a month in the stars pen in hand transferring to paper a monotony of skies. Now here comes snow.

December 3: A bit of snow removal with my kitchen broom and I can dial around the sky under the influence of the tranquilizing motions of drawing. My first asterism of the night strays from geometry to write: dog, dirty dog, kick him out of the room, when will the waiter bring more wine, words gushing from the pen in my hand. The handwriting, once again subjected to graphology's analysis, the cursive lines conjure someone steadfast yet imaginative, a defiant spirit frail of body. Further investigation indicates it's the handwriting of Caroline Herschel, you the first woman paid for science work, you scan night skies over England on this date in 1782. One year later, 1783: your vision magnified by your brother William's contribution of the longest telescopes and best lenses at this time, you identify a star cluster in the constellation Argo. One of the largest of Ptolemy's

constellations, demoted like Pluto, the ship Argo is now hull and
sails and stern and compass—floating parts no longer making a
whole. No matter. You're the Caroline Herschel of new nebulae:
one thousand catalogued and published in 1786, another thousand
published in 1789, a final catalog of five hundred and ten in 1802.
You're the Herschel comets, and the astronomer who's a musician
with an operatic voice and likes to sing kick him kick him pub songs.
And steadfast, you're the watcher outdoors in any weather in pursuit
of deep-sky objects for years of nights. The 31st of 1782, the ground
covered with snow, you fall, impaling your leg on an iron hook that's
lifting the twenty-seven-inch telescope built for you by brother
William. You write of the wound in a letter, one of hundreds of letters
from the hand of Caroline Herschel. Five hundred and one two, she
is identifying nebulae, the star-forming regions.

Notable astronomers Caroline Herschel and Annie Jump Cannon,
unbidden they have come calling. I know, yes, we all know: our
era is not big on contact with the dead; deliver us with evidence, of
which a fair amount is surfacing on my laptop. Lying in bed with
my view overhead buried in snow, December 23, I encounter a third
astronomer who never accesses my skylight, Henrietta Swan Leavitt:

 – American, woman, she lived from July 4, 1868, to December 12,
 1921.

 – She worked at the Harvard College Observatory, beginning in
 1892 with the job of quantifying specks of starlight.

 – She kept a journal, a record of her days at the observatory, of
 how cold was the day, of the lecture she attended, of frustration
 as a woman in the field of astronomy hired not to think, only
 to compute.

– At Harvard people claim to see Leavitt's ghost at her old desk, burning midnight oil. She is sitting in front of her wooden viewing frame that supports a glass photographic plate, then another and so on. "I pushed the sky around" is a Leavitt fact she never pens in spirit writing with my hand, though she has filled pages and pages with columns of numbers that are stars and with journal entries that go beyond the business of computing. As on a journal page from October 19, 1912: "tried superimposing Plate H361, exposure 10m, limiting magnitude 15.6 and Plate H385, isochromatic, limiting magnitude 14.9" and continuing for four more years of notation-filled pages.

Oh Be A Fine Girl Kiss Me. Dog dirty dog kick him out of the room, I wish the waiter would bring the wine. Two spirits writing with my hand and, in her former office, Herschel is burning midnight oil at her desk. Quaint phenomena—spirit writing and revenants—arriving through the agency of my skylight, my antidote to insomnia in a time when encountering life, life as envisioned by our technology our insistent prejudices and predispositions, is the primary prospect of outer space.

The brighter the star, the slower it blinks. You can judge a star's true brightness from the rhythm of its beat. Then you can compare that with its apparent brightness and estimate how far it is such that the distance of stars can be ascertained one to another. That is Henrietta Swan Leavitt's hundred-year-old discovery—it changed astronomy, it was used by Edwin Hubble to determine the universe is expanding, it is still in use to standard-measure distances from Earth to intergalactic spaces. And I read of this method: Carefully note the

position of a variable star, then measure it again years later, when the sun has dragged Earth and its inhabitants to a new location in space. Calculate the length of this enormous baseline, and then triangulate. With the distance of one variable star established, you calibrate Leavitt's yardstick and then measure the rest.

Carrying out calculations on that scale, that's a bit of a challenge, my nightsky, my view overhead, the stars I lie under, all those once-bright bodies in space … I'm in a tangle of information about millions of light-years measuring distance in time.

What is the date, what is my age on this night that exists only once? No matter. The biography of space locates us in the past, in old old light. The motion of light, its speed neither impeded nor accelerated by anything, I think that's the meaning of what I read tonight, taking my eyes off the skylight to delve into what cannot be seen in my visible patch overhead. Constant speed with nothing impeding or accelerating starlight's path, that's not believable.

Or perhaps I am tired. With neither sleep to impede, nor motion to accelerate the motion round the clock, my night has the constancy of old old light. My night is a long interval undivided by quarters, halves, no seconds ticking past. It could be two or four o'clock in the morning. A conspiracy moves across the galaxies, "always a few light-years ahead of nova heat," William Burroughs is saying in my ear. From the pillow next to my head comes a recording of his half-century-old reading, his voice the metronome of syntax keeping time. On it beat for beat I am on Bill's Nova Express, also am dialed in to variable and steady presences overhead—Jupiter unusually bright, crescent of moon, two stars pulsing. Count the blinks calculate the star's intrinsic magnitude compare with its apparent magnitude equals its distance, you can Leavitt the sky that way. You can oh be a fine girl kiss me see seven

spectral intensities. Sevens and sixes. A cosmological composition in six parts thinks Johannes Kepler, 1595, "… nothing but a kind of perennial harmony … syncopations and cadences … tending towards definite and prescribed resolutions, individual to the six terms (as with vocal parts)." As with *musica universalis*, music of the spheres mathematical harmonies heard in the lower region of the mental plane, those resonant proportions known to Pythagoras, to Plato, a second heaven to some religions registering whole tones as sacred geometry what Walter Murch says … ah, Murch the inspired sound man of cinema, brilliant-bright-luminous-observant-thoughtful-attentive not enough adjectives for the man with ideas in his ears. What Walter Murch says about planetary spacing is: "There is clearly something regular going on there, but exactly what it is or what is causing this regularity has eluded us. The curious thing, especially for me, is that the distance intervals predicted by Bode's law (1772), expressed as numerical ratios, are also musical ratios. No one has observed this before. Investigation continues." Great sky sleuth Caroline Herschel, across the wounded galaxies she comes, wailing "kick him kick him out of the room," so many commands pouring forth, "don't let them see us, don't tell them," the muttering Burroughs clocks another hour of his Express. Enter Giovanni Schiaparelli, 1877, thinking he's found canals on Mars. The astronomer in Giovanni detects Ursa Major, the Big Dipper, in a scatter of moles on the cheek of his niece, Elsa Schiaparelli. Her cheek's asterism outlined in rhinestones alights on her chest. Elsa Schiaparelli, lover of shining stones, she sets them to shimmer shoulders collars breast pockets, body-worn star patterns, her brilliant brooches. My stars' brightness is fading is gone. The sun, the light is an eraser.

NIGHTWRITERS

1987
SPOKEN TEXT BY CONSTANCE DEJONG
VIDEO BY TONY OURSLER
57:00 MIN.
PERFORMANCE COMMISSIONED BY
AND PREMIERED AT
ICA BOSTON, MASSACHUSETTS, 1988

I. PAINTING

The Albert Hotel in New York City has fallen on hard times. Oh, the building is still standing on lower Third Avenue, it's been standing now for two hundred years. No, it's the hotel's reputation that's come tumbling, tumbling down.

Still, from its best days in the late 1800s, one of the hotel's live-in residents, the American painter Albert Pinkham Ryder, has been remembered and remains with us to this day. Having acquired a reputation, gained recognition, Ryder's been lifted from the obscurity in which he ended his life. Even though those ups and downs of Ryder and the Albert reflect how the two have journeyed in opposite directions over time, both end up cast in roles that would be unimaginable, unrecognizable in their own era when day in, day out the life of the artist, the life of the hotel revolved around work.

A large and uniformed staff was forever dusting and polishing the hotel's endless surfaces of wood and mirror and brass. And under the same roof Ryder was busy with his surface, piling pigment onto a canvas already loaded with paint, producing such works as this, his 1896 painting titled *Constance*.

Via pure mental flights Ryder time-traveled to remote eras, returning with the content for a work like *Constance*, its theme taken from a tale of Geoffrey Chaucer's whose story is borrowed from Roman lore of the third century AD. To lift the depicted story from those remote sources, the official contemporary version goes like this: [reading] *The Persian husband of a Roman woman sets her to sea in a rudderless boat, leaving her to bob about for five years during which time she and her baby miraculously survived* [pointing to the painting], *as symbolized by painted light, returning unharmed at last to her lost home and wealthy family in Rome.*

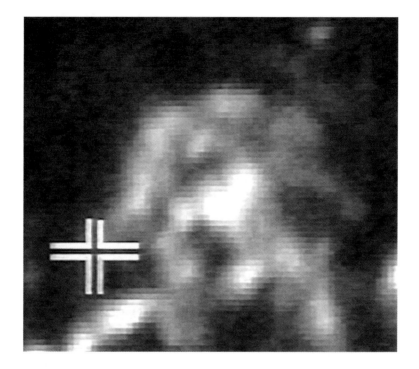

In real life the woman in this painting knew something of the sea. Ryder's model for *Constance* was Emma Trausch, my great-grandmother, a then-recent immigrant to the New World, New York, having crossed the Atlantic on a steamship after a long journey from the upper slopes of Transylvania. Emma was one of those uniformed polishers of brass and glass working at the Albert Hotel where she picked up extra money working as Ryder's model for *Constance*. Where then was her image, asked her family, none of them spotting the slightest resemblance between Emma and this pale painted woman adrift in her boat [*pointing to close-up of painting*]. Emma's claim to being part of the painting was considered as believable as those tales she'd dragged with her all the way from Transylvania. Like her favorite, the one about the young girl who becomes a village idiot.

A young girl falls asleep under a tree and wakes up with a terrible headache that never goes away due the insect that entered through her nose and deposited its eggs in her head. Time has not worn away the gruesome tinge of Emma's tale. And time has been good to Emma. She's been carefully preserved all these years beneath the painted skin of *Constance*. Now, Emma makes believers of us as slowly her image rises to the surface, as slowly Ryder's overloaded surface falls to flakes to the horror of professionals.

We in the family, we like what's been happening. Bit by bit a new painting coming out from under, ghostlike relatives peering out from behind loosening paint chips, fugitive pigments, and phantom shades. While professional restorers are busy speculating that perhaps the original bobbing boat was some kind of divan, that perhaps what's being depicted is a classic deathbed scene and perhaps symbolic figures of grief are gathered around, we in the family, we know what's certain. Here is great-grandmother Emma Trausch; that, her old iron bed, is no divan. Here, too, is Tante Marie, Uncle Johan, and baby Johanna.

As for what's being depicted, what we think: perhaps Emma is lying down because she's sick to death of all that dusting and polishing; of Uncle Johan losing money again at the track or on some miracle cure of his involving helium. Or perhaps this painting is of Emma convalescing from her own miracle, her incredible survival after being struck by lightning on a downtown pier where she stood talking to Uncle Johan standing not two inches away and not a scratch on him, the guy who always came out on top. Or this could be a real still life. Emma is on her deathbed taking family secrets to the grave, something about Uncle Johan, Uncle Johan, always Uncle Johan, our skeleton rattling in the closet.

Meanwhile Ryder's flakes are falling. And *Constance* is deteriorating into the future. An ever-so-slightly moving picture, slow, slow-motionally changing over time into 1990, the year 2000, 2010.

MIGRATION – WEATHER MAP 1

In 1920 many a young face was turning to the West, to Hollywood, last stop for trainloads of young hopefuls traveling American song lines from sea to shining sea, from the mountains to prairies to the ocean white with foam. Out here in 1920 the forecast was sunny. And Pico, Van Ness, Santa Monica, Wilshire, streets out here were called boulevards lined with palms and the color of money, and one by one the hopefuls came to walk the boulevard of dreams where the wind is full of stardust, puffed with hype blowing hot, blowing cold. When the dust settles it's drifted across a plaster desert, painted landscape, cardboard village, and all is quiet on the set [*pointing to migration – weather map*] on this western front where the stars are coming out one by one. The big box-office names in Hollywood are known collectively as the Glamour Galaxy, promoting their status as celestial bodies orbiting above those extra bodies needed to populate, to set the scene in motion.

II. BLACK & WHITE MOVIES: 1920s

Many a night I sit watching these same scenes in forward and
reverse motion, searching back and forth for one of those star-
dusted extras, my grandmother Johanna Trausch, that baby in the
Ryder painting who stepped off his painted surface into a world
of light and movement, of motion pictures 1920s style, full of
commotion, extras, so many extras. Difficult as it is to tell one extra
from another, I believe I recognize Johanna from a family photo—
here, let's see, oh good idea, let's rewind and OK ... yes! Here she
is all right in what might be *The Half-Breed* or *The Firefly of Tough
Luck* or *The Price She Paid*, names of films Johanna mentioned in
one of her first letters sent home.

LETTER #1

[*reading*] August 21, 1920. Dear Mama, I really wish you'd stop
hounding me about everything you read in the scandal sheets.
I couldn't even finish that horrible story you clipped for me, the one
about the DeLorean twins. I'd actually met those girls, I can't believe
they'd commit suicide without telling any of us. We all got work
together in *Twilight Baby* over at Fox. I don't want to think about it,
that's my point Mama. I'm having trouble enough keeping up my
spirits. It's not easy just being a face in a crowd. Yes, that is where
you'll find me all right. But at least you can find me up there on the
screen, at least I'm working, working real hard in fact and with a lot
of stars like Barbara La Marr and Mae Murray and Alma Rubens in
The Half-Breed and *The Firefly of Tough Luck* and *The Price*...
Oh look [*pointing to film close-up of extras on-screen*], here she is again,
that's her all right. But not for long. For soon gone forever is Johanna
Trausch the eighteen-year-old hopeful who boarded the Hollywood
Express and transformed herself into a starlet named Lorna Lanne,
a name she signs with a flourish in lavender ink on the bottom of
now-scented letters sent back home.

LETTER #2

[*reading*] Dear Mama, Do you know the name Cecil B. DeMille? He's a very great film director and I was just cast in his next film, *Cleopatra.* You're the first to hear my great good news, that's the way I wanted it. I wish you were here to celebrate with me. I was just on my way to a party, sitting in the back of Alma Rubens's Pierce-Arrow if you can believe it. I know you know Miss Rubens, the whole world knows. With Miss Rubens's help the world will know me, Lorna Lanne. Yes, that is me all right, your very own daughter. Can you recognize me from the photo I sent? In a way I hope you can't, because if my own mother can't recognize me then I'm sure Miss Rubens has been a success with my makeover. Do you like my hair in a bob? It's a darker shade of black, "raven" it's called. Miss Rubens says this way I look less like a person and more like a person on the screen. I have to agree with her, if you want to be in movies you have to look the part. Lorna Lanne has a look all her own with her very own trademarks. She's never seen wearing anything but blue and silver, she powders her face with talc until it's dead white, word has it she eats nothing doesn't fall from a tree or spring from the earth. Remember very soon Lorna Lanne can be seen in the latest release from movie czar Cecil B. DeMille along with Hollywood's number one money-making star, Claudette Colbert in *Cleopatra.* Tell everyone. Tell everyone. I'll write again soon, sending love.

RELATIVES

Many years passed between the writing of that letter and the appearance of my grandmother in this 1963 remake of *Cleopatra* starring Elizabeth Taylor. Many a sad story is secreted in this tiny screen moment when Lorna Lanne tosses her torch into the air, still among the extras. Difficult as it still is to tell one from another, with the aid of handwriting analysis I can see through the tight loops and reverse slope of Grandmother's script. And when the messages encoded in her handwriting are unlocked, they sound like these lines from *Hollywood Babylon*.

Here is where you'll always find me, always walking up and down. But I left my soul behind me in an old cathedral town. The joy you find here you borrow. You cannot keep it long it seems. But gigolo and gigolette still sing a song and dream along the boulevard of broken dreams.

MIGRATION – WEATHER MAP 2

The wings of desire set the wheels in motion again. And in an old
beater a branch of the family cuts and runs. Driving from the
West Coast through the prairies, the mountains, they were driving
to where they would stop none of them knew. From Winnetka
to Waukegan, from Coshocton to Cuyahoga Falls, the wheels of
fortune stop here: Cuyahoga Falls, Cleveland.

III. ELECTRIC BUG-ZAPPER TIME

Coschocton, Gnadenhutten, Tuscarawas ... oh, it's beautiful Ohio
full of strange-sounding names. It's beautiful Ohio full of cars. As a
kid—you get two sets of memories. In one you're in the car, it's always
Sunday afternoon, day of no-rest family outings. Click—there's
me and my sister at the Indian mounds; click—me and Dad in the
doorway of a pioneer village; click—Mom in shorts next to Johnny
Appleseed's monument. Then you're in the backseat-psyche quiet
time. It's always twilight. You're driving home through a sulfur cloud.
Wherever you look: mills, factories, your erector set gone crazy. And,
always, the fire. Fire in the sky shooting out of smokestacks. Fire
on water, the Cuyahoga River burns. Its feeder creeks are chartreuse
water piled with floes of acid-orange foam. But from this you shall be
delivered. You, there, reading into the night with your flashlight; you,
little girl, reader of illustrated articles that declare goodbye industrial
age, hello technology sunrise. You will live in a Lucite tetrahedron,
wear a uni-suit, eat dinner pills delivered by your robot. The effects of
evolution and leisure time will be visible in your enlarged head size as
you undergo change at the speed of life. These highways? They shall be
a leisure site, too, with your remote-controlled vehicle hovering over
a magnetic strip. Your round little pleasure-ship of a car will always
be on course, leaving you free to sit around playing a brainy transistor
board game. And on what course are you set?

RELATIVES

My sights are on creatures unknown to me, on animals roaming wild, nothing like captives on the *Zoo Parade* show I watch on television. I imagine roaming without fear among the animals, lying down with wild things on the ground. I imagine having a hand in TV shows with kids from distant worlds, from way beyond the Earth's atmosphere where, among unnamed beings, I go roaming— a citizen of the universe.

Look. Up in the sky. A bird, a plane? Is it a young girl capable of leaping tall buildings in a single bound; of streaking across an empty black sky, backdrop to my favorite neighborhood haunt: my very own vacant lot full of broken Coke bottles and dead refrigerators— that's the stuff Midwest dreams have to be made of.

[*in black*] The time is 1957 on a Saturday morning … almost time for my Uncle Johnny's kids' show on television.

IV. EARLY REGIONAL TELEVISION: 1950s

BEANIE [*hand puppet / Tony Oursler*] Hey there, hi everyone. Give me five now. You know what that means: count to five and Beanie comes alive. OK—one for my head; two for my mouth; three an eye, four an eye; five here's my hat and that's that. That's how easy it is to play make-believe. You hardly need anything at all. Just your imagination. OK, now let's count again. Today is Saturday, October 20th. How many Saturdays is that so far this month? One—two—three: the third Saturday in the month and you know what that means. It's viewer mail day. As always, our friend Gracie is going to help us out. Hey, there's Gracie right now. What did you find in the mail today?

GRACIE [CDJ] Well, Beanie. This week the mail brought you a very beautiful picture postcard from Tracy Kaiser. Tracy lives in Chagrin Falls. She asks: Where does Beanie come from?

B Well, you know when you ask someone where they come from, they usually tell you the name of their hometown, the place where they were born. Because children, and animals, too, actually are born, so they come from their mothers and fathers. And then there are some things that are not born. Some things are products of the mind, they're inventions, things you see every day …

G Like your school bus.

B Or your television set.

G Or even your toothbrush is an invention, a product of the mind that helps you have good health and long life.

B Now there are also things that are products of need, things
you can't live without, like food and clothing and shelter, basic
necessities. And we always need stories. So to answer your
question, Tracy—where did I come from?—brings me to an old
old question: Which came first, the TV or me?

Did you ever wonder where television comes from? Well
that's a really interesting story. And today, as usual, this will be
one of our stories we tell together. I wish I could hear you, like
you can hear me. Remember you've got a big helping hand in me.
So, let's begin our story, you and me.

Remember, when I leave the blank spaces, the important
thing is for you to talk for you and your friends. Because you're
part of the picture, too; the whole picture going into your living
room with you and the TV in it.

Now. Did you know television was first imagined by a little
boy? That's right, a little boy named Philo T. Farnsworth. Philo T.
Farnsworth was from Iowa where they grow lots of _____?

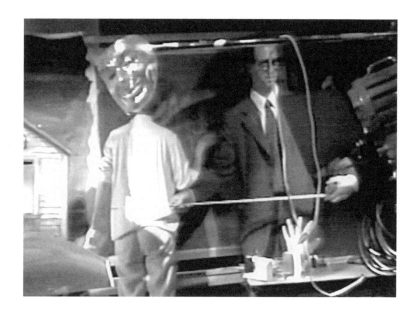

G Lots of the pioneer spirit.

B And every ear of corn has lots of_____?

G Isn't it true that RCA stole Farnsworth's patent?

B And the kernels in an ear of corn are lined up in _____?

G Wasn't Farnsworth unhappy with the uses made of his patent?

B Now would you believe this is where television comes from?
 Well, the rest of the story goes like this: Little Philo grew up
 listening to radio. He understood that sound is waves passing
 through an electrode tube. And when he saw corn growing in
 rows, he imagined that pictures could be lines and dots passing
 through a tube and that would be television.
 Now I think if we always tell our story our way, we can live
 up to the splendor of this invention. And maybe in the future we
 can talk back and forth through the tube, maybe one of you will
 invent that for us. I have to go now. There will be commercials.
 See you next week.

CDJ Cigarettes, cars, soap ... the man who railed against his sponsors,
 who called them fat cats boobs lunkheads, who said barons of
 money rob the world of value, there you see him. John McCloud Sr.
 Righteous disdain, that was the downfall of this award-winning
 pioneer standing at the threshold of early television. My uncle
 Johnny, ever tinkering junk-nothing into cool-something, there he
 is taking a long slow nose-dive out of the TV picture, that once-
 regional forum of faraway places with strange-sounding names.

V. THE FAMILY CREST

Father to son, father to son. A son formally salutes patrimony in traditional pictorial language, here in the red gloved hand, the work of my cousin George who issued the following proclamation.

I, George McCloud, firstborn son of the much-honored Johnny, hereby entitle myself to emblazon the family identity in a suitable coat of arms. A case of using logic to get to logo. For what precisely is a logo, if not a contemporary coat of arms meant to be seen from great distances at high speeds.

At a glance, one recognizes the traditional medieval-crest shape in the outline of Ohio: an updated graphic that literally puts the family in its place. Within the simple geo base there is room for complexity, for imaginative vistas. Imagine the short lives of medieval people as analogous to our era's short-lived marriages. Then, as now, multiple fathers enter the picture and leave their mark.

Spark plug. Here the mark of a mechanically minded man, my first stepfather, William McCloud, who had been my uncle Bill, my father's long-widowed brother. Rumored to have carried a torch for my mother, William extended the family name into a new chapter. Into the fold came William's children from his previous marriage, effecting role realignments as cousins became brothers and sisters.

William became something of a phantom thanks to the long hours he put in as a garage mechanic working on his idea, the fuel-less motor. William believed in deriving energy from natural processes, from lightning fields was one idea, and later from the Earth's magnetic field.

Paper clip. Here the mark of my second stepfather, Jonas Gray, certified public accountant. In his flannel suit he tried to teach us the meaning of life with its time allotments going off on the hour: when one sat down to dinner, left for work, caught the same train home every day and got the same haircut every other Saturday while one's shoes were being polished. That last shoe-haircut entry was a lesson in how a head-to-toe event, a twofer, could be completed in a single time allotment on the clock.

Yellow rose. Symbol of my mother, of Mother's successful efforts to grow cream, ivory, lemon, xanthic, golden, over thirty-two shades of yellow in ever-multiplying garden beds, her four-by-six dirt canvases, one of which conjured family discord: a love triangle in Mother's bed of roses planted with three varieties of blooms representing her husband, the other woman, and Mother was the prize-winning, the piss-yellow rose flushed with red.

The mockingbird. A beloved family pet was no less a symbolic lovebird in a true story of love between Rosemary and Roger McCloud, two of those once-cousins who became brother and sister, fell in love, and remained branded as delinquents in the eyes of our neighbors. In truth theirs was the unusual choice of enduring unrequited love. Vowing to remain forever as unmarrieds, living

their separate lives, all the while destined to cross paths again and again as their beloved pet was shuttled back and forth through years of joint custody.

Blue. The color field of our crest, the age-old symbol of fidelity was much required by children who had never known my biological father and were called upon to embrace him when back to the family home he returned. Easier there to undergo the sufferings of old age, the effects of his many excesses. One result of excess came with him to the house, a two-year-old baby girl named JoLynne, a child who tested family fidelity, who had little effect on forty-year-old me, perennial bachelor, keeper of the keys, I say: red for love, green for hope, white for charity, the emotive values of colors, of symbolic animals and plants—I am compelled to arrange my elements as a magnet that attracts from a pile of things.
The number eleven. In this figure which attracts me like no other the identity is concealed and yet revealed. The number eleven could symbolize two solitary souls standing side by side, the pillars of society, the twin aspects of Gemini … I will never tell. A man is entitled to venture beyond the family circle, to enter a brotherhood of man through initiations that have sworn me to secrecy. I have been led blindfolded down carpeted passageways to the thumping of mallets, the clanging of bells, holding a sword against my chest, emerging from these rites of passage as a descendent of the Mysterians. Keeping secret is the key to our society. Whatever is done to me. Whatever name is hurled at me. I will remain true to my motto: *stato quocumque jerceris*, wherever you throw me, I will stand. [CDJ *covering some of the letters*] Really looks like "status quo" to me. And, for a time, that girl-child JoLynne, a static view of the world she was destined to see. You know, the way it's supposed to be: one mass-audience family. They say, behold.

STATO

QUOCUMQUE

JERCERIS

VI. 1950s BLACK & WHITE TO '60s COLOR TV

Behold a world absent of color, absent of social conflict. Red, yellow, black, brown. If certain people fall outside the problems with which everyone can identify, if the social roots of conflict are invisible, where is the need for such concepts as unity, organization, struggle? Indifference, passivity serve to maintain the status quo.

But the TV appliance comes with a volume control.

Behold a world in which human nature is unchanging. The market for shows comparing human behavior with animal instinct is booming. The media shall see to it that everyone has the opportunity to see and hear the latest theories linking urban crime to the predatory behavior of large four-legged carnivores. If we are doomed forever by our animal inheritance, where is there anything to be done about it? Pessimism serves to maintain the status quo.

But the TV appliance comes with a channel control.

Behold a world of choice unending. The media, they say, is an aggregate of independent entrepreneurs. If the messages and images just happen to serve the same ideals, where can there be an objection to private ownership, free-market controls? Pluralism serves to maintain the status quo.

But there is a color control.

[screen becomes psychedelic TV mandala/feedback]

And there is JoLynne and friends who have—in a way—seized the controls, added their own soundtrack, their own color, and in their own words they say: We refuse to be folded, manipulated, spindled. We, we are family, wooden ships on the water very free. You know, the way it's supposed to be. Talking about very free and easy.

So, you better think; think about what you're trying to do to me. Yeah, you better think; let your mind, let yourself be free. Freedom, freedom's just another word for nothing left to lose. So, let me sleep all night in your soul kitchen. And say, are you experienced?

Are you really experienced? Go ask Alice when she's ten feet tall. And when the music's over, turn out the lights, turn out the lights, turn out the lights. So sing the song, don't be long. You there, Sunshine Superman, Mr. Mojo-Backdoor-Tambourine Man, you say no. But I say go, go, go. 'Cause he who isn't busy living is busy dying. Hell no, no, you don't need a weatherman to know which way the wind blows

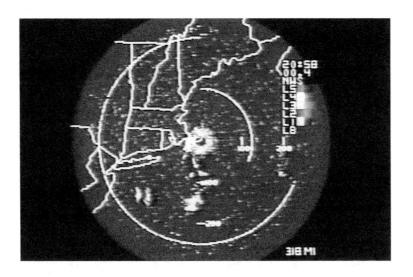

MIGRATION − WEATHER MAP 2

The night sky is filled with earthly evidence, with the lights of
Airbuses, of satellites tracking national and natural forces. And with
the less-visible evidence of Apollo, Mercury, Gemini—ships named
for an old democracy's myths.

For my older sister Rose, the only way to kiss the sky was with
her feet on the ground. A victim of wanderlust contracted at an early
age, my sister left home to trek the world around. In her down parka
she was comfortable in regions formerly inhospitable. She followed
ancient corridors of migration, older than the nations the birds flew
from. A trekker of mountains with long four-syllable names, some
with just numbers for names, she gulped the view from the top.
When finally she chose to rejoin us down below, my sister returned
to a world filled with evidence of the places where she'd traveled;
filled with Toyotas, Trinitrons, video cameras, products with labels
that read *Made in Japan*, *Made in Hong Kong*, *Made in China*. Ever
resourceful, my sister made a living performing lines in English as an
actress meant to be heard but not seen as America dubbed kung fu.

VII. KUNG FU FILM: 1970s

[Take 1]

HIM All right, that's enough now.

HER Yes, honorable one.

HIM Come inside, now.

HER OK. [up the stairs] You know, I wasn't going to fight you.
I wanted to protect you. That man, I thought he was a thief.

HIM You can tell I don't fight.

HER Oh yes.

HIM Hey, your style, what's that?

HER First I use kung fu. Then more kung fu. Always kung fu.

HIM [*sighs*]

HER What's wrong?

HIM That's not nice.

HER Everything concerning kung fu is nice.

HIM Oh.

HER Kung fu is a noble art.

HIM Well, possibly it is. But it leaves your blouse open, people can see.

HER Oh, but no people are here. This is a private demonstration for you only.

HIM Well, maybe. But still it isn't very nice, not for a girl, it isn't very elegant.

HER Don't Chinese girls ever show any spirit, any fight?

HIM Yes, they do, but they always remain poised, relaxed. Here, I'll show you. Like this.

HER Hmmmm.

[*Take 2*]

HIM All right, that's enough now.

HER You're talking to a fighter.

HIM Well, come inside.

HER Yeah, yeah. [*upstairs*] Listen, you'll be safe around me. I only
strike the deserving, you're no threat.

HIM You can tell I don't fight?

HER You bet.

HIM Hey, your style, what's that?

HER It's the style of the oppressed, of female spirits dwelling in me,
a noble possession.

HIM [*sighs*]

HER You know, we could kill you.

HIM That's not nice.

HER Nice is the power in me, the time of overthrow is near.

HIM Well, possibly it is. But it leaves your blouse open, people
can see.

HER People see ancient biology, this is possession evolution.

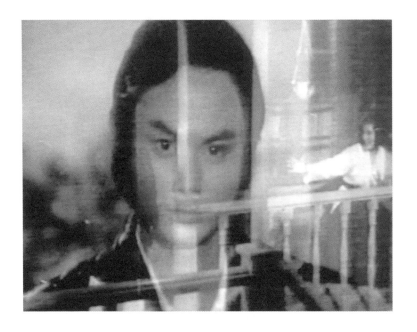

HIM Well, maybe. But it isn't very elegant, not for a girl …

HER It's very elegant to be a warrior for your sex. I suppose you think baby girls should be killed at birth.

HIM I know Chinese girls. They always remain poised, relaxed. Here, I'll show you. Like this.

HER Oh my.

RELATIVES

VIII. VIDEO GAMES, NUMERIC SYSTEMS, LOTTERY, FRACTALS: 1980s

Where my older sister made a living giving voice to the English language, my niece Carol is enmeshed in numeric systems. Meaning anything of, relating to, or containing numbers.

Hour after hour Carol sits with her back turned to the world, her hair matted and smelling of warm plastic—of poorly ventilated rooms warmed by disk drives and flickering monitors.

Carol has worked on programs that bring order and harmony to the world:
- bar codes that classify vast inventories
- zip codes that hasten delivery of purchases
- sequences that ensure no two people have the same credit card number

In her spare time Carol has made numerical portraits of everyone in the family, using a program that ciphers personal information into digits. My portrait by numbers is: 37-25-12-9-13-2 where 37 is the sum of 8-5-1-9-4-7-3, the numerical values of the letters in my first name.

But we are drawn to monetary values. For Carol uses us to play a weekly game of chance. Her method. By stacking numerical portraits of six family members one on top of another, Carol produces long columns of numbers, like recombinant DNA— a genetic pool of numbers that's yielded lottery winnings for many a relative. Every week Carol conjoins a selection of our portraits, different combinations and permutations. How things line up, how things fall apart, these questions are at play in Carol's fascination with randomness and chance.

[first-person combat video-game montage]

If the question of how you play is whether you win or lose, then capabilities count more than intentions. Especially having the capability to inflict more damage on the opposition than it can inflict on you. If everybody fires everything they have, we'll have survivability based on a belief in the ability to survive a counterforce attack and still deliver a crippling retaliatory blow. Or, said another way: if you attack me, it may kill me, but I will kill you before I die, unless by attacking first I can seize the advantage with the intention of displaying superior capabilities … since capabilities count more than intentions. Especially having the capability to inflict more damage on the opposition than they can inflict on you. If everyone fires everything they have, we'll have survivability based on a belief in the ability to survive a counterforce attack and still deliver a crippling retaliatory blow.

 Or, in other words: if you attack me, it may kill you, but I will kill you before I die, unless by attacking first I can seize the advantage with the intention of displaying superior intentions … since capabilities

count more than intentions. Especially having the capability to inflict more damage on the opposition than they can inflict on you, so if everyone fired everything they had, we'd have survivability based on a belief in the ability to survive a counterforce attack and still deliver a crippling retaliatory blow. Or, if you attack me, it may kill me, but I will kill you before I die, unless by attacking first I can seize the advantage with the intention of displaying superior capabilities ... since capabilities count more than intentions. And so the game plays on.

As Carol once instructed me: the game is child to the programmer, is an electromagnetic offspring displaying characteristics of the parent. She certainly hasn't replicated the inclinations of her mother to trek all over the world. No, Carol is content to sit at her computer terminal mapping her own genealogy.

RELATIVES

Using a familiar theorem, that any two people can be connected through three intermediaries, Carol plots her personalized lineage, linking herself to others fluent in the language of numbers. Among them: Leonhard Euler, the most prolific mathematician who ever lived; Caroline Herschel, who calculated over 2,500 nebulae; Georg Cantor, the father of imaginary numbers.

Becoming one with her warm plastic terminals and all things numeric is how I imagine my niece, always in sync with her codes and algorithms, sitting there tuned to speed and powers at trillions of operations per second.

As a basic computer user, I know cut-and-paste, save and retrieve, send delete return, click click click. Beyond that, to say anything of techno-consequence would have me far out on a limb. And from which limb would I dangle?

The expert Carol informs me my choices are infinite. With one of her fractal programs, nature is converted to numbers and the computer is a greenhouse spinning out endless limbs on ever-changing trees. The fractal is a way of seeing infinity. Infinity. The way the computer keeps me dangling, just keeps me hanging on.

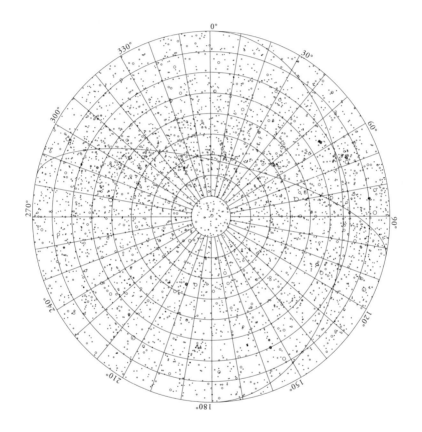

P. 6: From *Nightwriters*, 2017–18. Courtesy of the artist.
P. 35: Constance DeJong, *I.T.I.L.O.E.* (Top Stories #15, 1983), book cover (detail). Photo by Anne Turyn.
P. 41: *Pink Knight Roland*, 2015. Photo by Weston Lowe. Courtesy of Bureau, New York.
PP. 43–47: *Messages to the Public: Ally*, 1988. Photos by Jane Dickson. Courtesy of the Public Art Fund, New York.
P. 79: *Green Crosley*, 2017–18. Photo by Weston Lowe. Courtesy of Bureau, New York.

Editor: Rachel Valinsky
Design: Freer Studio
Copy Editor: Allison Dubinsky
Printer: Ofset Yapımevi A.Ş.

Primary Information
232 Third St., #A113
The Old American Can Factory
Brooklyn, NY 11215
www.primaryinformation.org

Primary Information and the author would like to thank Lia Gangitano at Participant Inc.; Gabrielle Giattino at Bureau; Anne Hawley at Isabella Stewart Gardner Museum; Jill Medvedow at the Institute of Contemporary Art, Boston; Diane Shamash at Minetta Brook; Anne Turyn at *Top Stories*; Tony Oursler, collaborator on "Relatives"; Peter Russo, Lucy Ives, and Molly Kleiman, editors of "Nightwriters" at *Triple Canopy*; Betsy Sussler at *BOMB Magazine*; The Kitchen; and the Public Art Fund.

Primary Information is a 501(c)(3) non-profit organization that receives generous support through grants from the Michael Asher Foundation, Empty Gallery, the Graham Foundation for Advanced Studies in the Fine Arts, the Greenwich Collection Ltd, the John W. and Clara C. Higgins Foundation, the Willem de Kooning Foundation, the Henry Luce Foundation, Metabolic Studio, the National Endowment for the Arts, the New York City Department of Cultural Affairs in partnership with the City Council, the New York State Council on the Arts with the support of Governor Andrew Cuomo and the New York State Legislature, the Orbit Fund, the Stichting Egress Foundation, Teiger Foundation, The VIA Art Fund, The Jacques Louis Vidal Charitable Fund, The Andy Warhol Foundation for the Visual Arts, the Wilhelm Family Foundation, and individuals worldwide.